NORTH STAFFORDSHIRE

THROUGH TIME

Mervyn Edwards

AMBERLEY

Acknowledgements

Julie and Peter Bagnall, Bradwell Methodist Church Archive, The Chatterley Whitfield Archives, Annette Eeles, Bertram, Beryl and Ray Follows, Rosemary Gidman, Gordon Howle, Liz Lambert, Mary Mae Lewis, Keith Meeson, Laura Morrey (née Butler), John Mulden, the National Monuments Record, Norman Scholes, Alan Self, Jennifer Stoker, the Waterways Museum, Alan Townsend, Mrs Willot of Fenton, Chris Wilson.

First published 2024

Amberley Publishing
The Hill, Stroud, Gloucestershire, GL5 4EP
www.amberley-books.com

Copyright © Mervyn Edwards, 2024

The right of Mervyn Edwards to be identified as the Author of this work has been asserted in accordance with the Copyrights, Designs and Patents Act 1988.

ISBN 978 1 3981 1371 8 (print)
ISBN 978 1 3981 1372 5 (ebook)

British Library Cataloguing in Publication Data.
A catalogue record for this book is available from the British Library.

Origination by Amberley Publishing.
Printed in the UK.

Introduction

In history, everything connects to everything else. So after Amberley published my last title, *The Potteries Through Time*, my immediate thought was, 'Why stop there?'

I live in Wolstanton, Newcastle-under-Lyme, which is virtually equidistant between the Potteries and Newcastle town centre. Though they are governed by different unitary authorities, they are seen by many people as a part of a conurbation comprising towns and villages that share common interests and features. The business activities of master potters such as Josiah Wedgwood and Josiah Spode extended well beyond their factory gates in fuliginous Stoke and their historical footprint can still be detected in the present town centre of the neighbouring loyal and ancient borough. A century later, manufacturers who had grown rich on the back of industrial endeavour in the Potteries chose to live away from the towns their factories were polluting, in areas such as Basford, Porthill and Wolstanton.

The history books tell us that Wolstanton was annexed by Newcastle in 1932 but few mention that if history had taken a different turn in the previous century, then Burslem might have annexed Wolstanton and become a county borough. Debates surrounding remain/leave raged long before the 2016 European Referendum, with the makers and shapers of Burslem wielding much influence in Wolstanton, helping to establish new clubs and societies and in doing so blurring social, political and geographical boundaries. Pottery manufacturer John Wilcox Edge was referred to as 'the Grand Old Man of Burslem and the Potteries' when he died in 1923 and when living on the Watlands estate in Wolstanton, he had championed Wolstanton's absorption by Burslem. The estate was home to numerous captains of industry including Samuel Gibson, the Burslem pottery manufacturer (d. 1914); Leonard Grimwade, the Stoke pottery manufacturer (1931); pottery designer Joseph Albert Wade (1933); and Arthur Best, the Trubshaw Cross china and clay merchant (1949).

Enough about clay. Coal and ironstone reserves were plentiful locally and we are reminded that the North Staffordshire coalfields embraced not only the Potteries area but small fields at Cheadle, Goldsitch Moss and Shaffalong. Beer brewed by Joule's in the Canal Town of Stone was sold in many Longton pubs. The inland waterways themselves were the great connectors of commerce and people, whilst the railways established by the North Staffordshire Railway Company similarly broke down barriers and created new industrial hubs. The A500 urban expressway – known locally as the D Road and often derided – connects the Potteries with Cheshire. Travel has indeed broadened our minds and engendered a greater collective consciousness that gives fresh perspective to local struggles.

This book features the Potteries but ventures miles beyond it in offering images of other North Staffordshire locations with which – one way or another – Stoke is inextricably connected. Parochialism is far from dead in these parts, but North Staffordshire's rich and variegated history and geography persuaded me long ago to cultivate a knowledge and interest in what could be found well outside my front door in Wolstanton. I hope you enjoy the book.

Mervyn Edwards

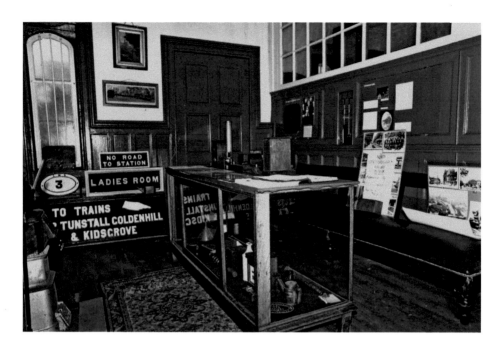

Cheddleton Railway Station Booking Hall, date unknown
This photograph was taken in order to recognise the hall's refurbishment. Memorabilia is displayed recalling the 'Knotty' – the North Staffordshire Railway Company whose insignia was the Staffordshire Knot, which had been adopted as its motif. The station was reputedly designed by Pugin. It operated between 1849 and 1965 and is now a preserved station on the Churnet Valley Railway in Staffordshire.

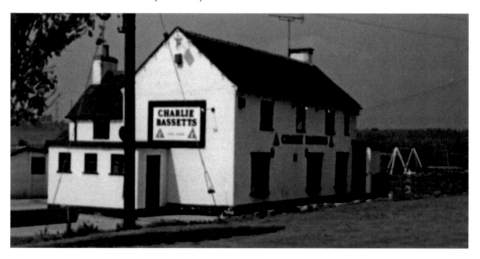

Charlie Bassett's, Dilhorne, 1990s
Here is a North Staffordshire pub located halfway between Stoke-on-Trent and Cheadle. Historian Kevin Salt, speaking to *The Sentinel* newspaper, revealed that the former Colliers' Arms was in 1947 taken over by a local man, Ralph 'Charlie' Bassett. It closed in the early twenty-first century but was subsequently reopened in the summer of 2010 as the White Lion. Local couple Kevin and Yvonne Ball bought the pub premises from brewery Thwaites in 2014 and revived the name of Charlie Bassett's.

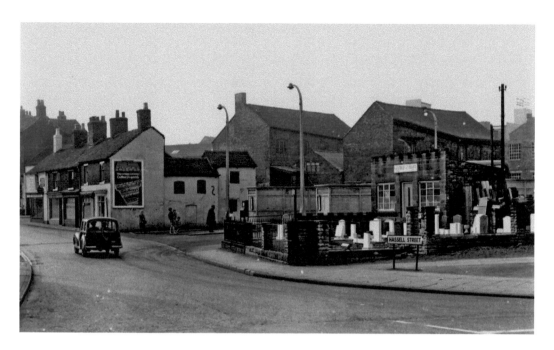

Hassell Street and Bus Station, Newcastle, 1969 and Same View, 2022
George Owen Burt, a monumental sculptor/mason, traded at No. 33 Hassell Street under the name of Castle Memorials, and a *Sentinel* advert of 1950 ran, 'Our family has served the people of North Staffordshire for more than 100 years.' The building displaying a Cadbury's advert on its side would become Maggie's Corner around 1970. At this time, buses negotiated quite a tight corner in turning past Burt's into the bus station. Newcastle's bus station is now located on the opposite side of the road.

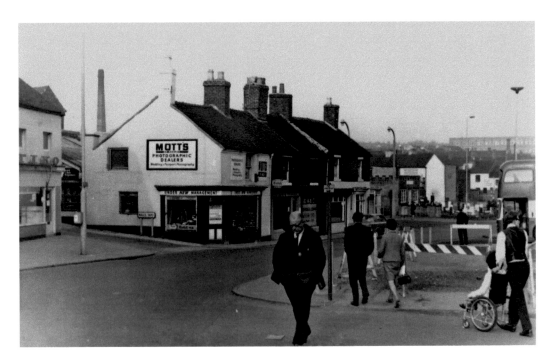

Hassell Street and Ball's Yard, Newcastle, 1969 and Similar View, 2022
Mott's photographic dealers became Newcastle Camera Centre in the 1970s. A well-remembered Hassell Street trader was Maggie's Corner, a gift, craft and cane specialist, which had traded in Newcastle for almost thirty years and on its Hassell Street site for eighteen. Maggie Golby died in October 1997 and the shop, which had moved from its original site, closed in 1998, later becoming the Revolution bar. Roughly adjacent were the Hassell Street public toilets, located underground and accessed by steps.

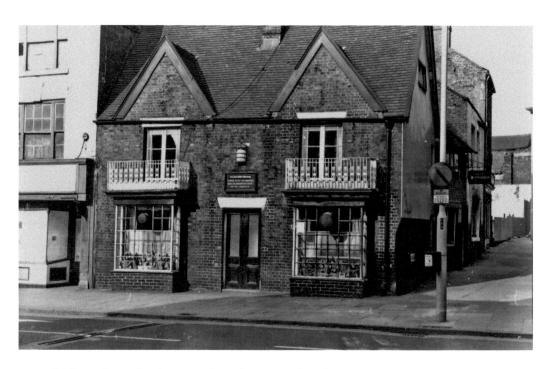

Hind's Vaults and Lad Lane, 1969 and Co-operative Shop, 2022
A sad casualty of the reckless redevelopment of Newcastle in the 1960s was the former Golden Barrel, whose later name, the Hind's Vaults, recalled a one-time landlord. This was a timber-framed building with a double-gabled frontage that was later faced with brickwork. It featured projecting bay windows topped with ornate cast-iron balustrades – a likely addition of 1843. It could boast of a magnificent cellar. The pub was demolished in 1969 despite Newcastle Civic Society's campaign to save it.

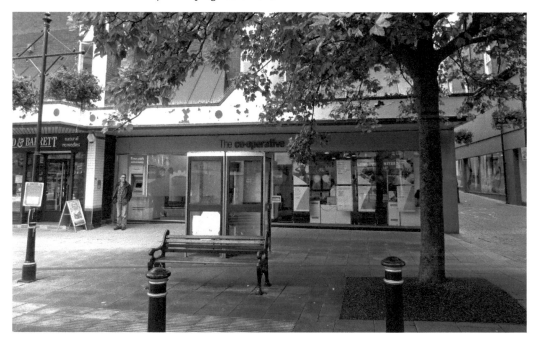

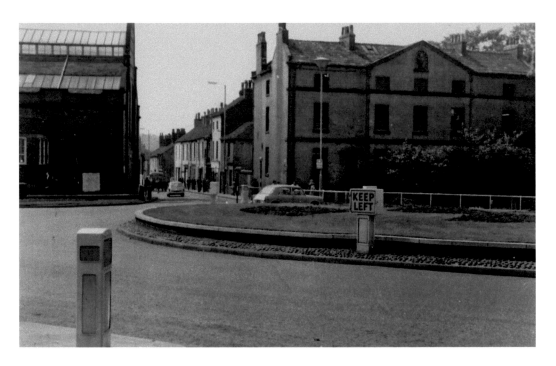

Borough Treasurer's and Nelson Place, 1967 and Similar View, 2022
The building to the right in this view of Nelson Place is described in the Victoria County History as a house of *c.* 1800 with an impressive stucco front of five bays. In the pediment was a bust of Admiral Nelson that was later removed to Newcastle Borough Museum. This became the Borough Treasurer's office and was situated between Barracks Road (centre in this picture) and Ironmarket. The building was captured by renowned artist Gordon Forsyth in a watercolour painting of 1943.

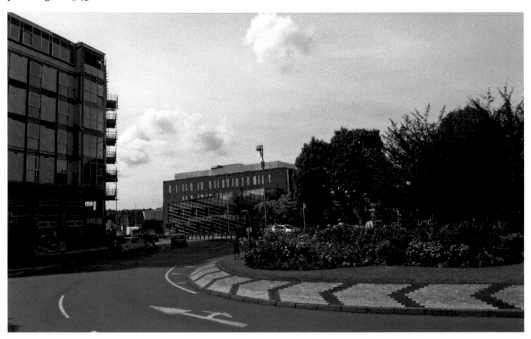

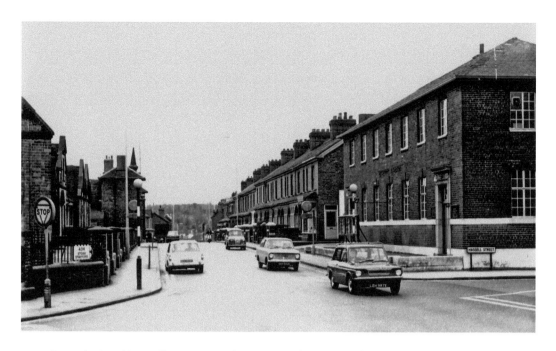

Barracks Road/Hassell Street Junction, Newcastle, 1967 and Similar View, 2022
Hassell County Primary School appears on both photographs though Barracks Road (formerly Bagnall Street until 1954) is much changed. Another survivor has been the Militia Barracks of 1855, situated a little further on – once the headquarters of the town fire brigade. Among the shops that formerly traded in this street were Palmer's timber merchants (later Howarth's) and James Shaw the glazier. Wholesale demolition took place in the interests of road widening, shortly after the 1967 picture was taken.

Merrial Street looking towards Nelson Place Roundabout, Newcastle, 1972 and Similar View, 2022
The garden area on the left belonged to the Ebenezer (Methodist New Connexion) chapel which opened in 1858 – a magnificent expression of Nonconformist affluence designed in the Classical style and incorporating a handsome pediment. From the outset, it was envisaged that the ground in front would be planted with trees and shrubs. In 1981, the chapel closed and the building was renamed Ebenezer House. Grade II listed in 1972, it has since been used for retail and office accommodation.

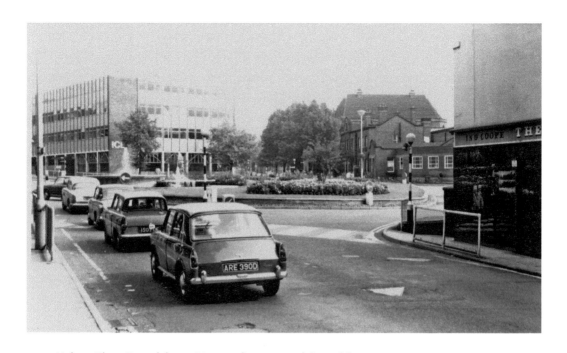

Nelson Place Roundabout, Newcastle, 1972 and Same View, 2022

Both of these pictures feature the Nelson Place roundabout whilst the older picture clearly shows the corner of a public house housed in a Georgian building. This was the Compasses, which changed its name to the Crossways in 1974. It became the Queen Victoria in 2003 and the Lace Gentlemen's Club in 2007. Following a period of closure, it was reopened as the Crossways by the BottleCraft craft beer company in 2021. In the distance is the ICL (International Computers Limited) building.

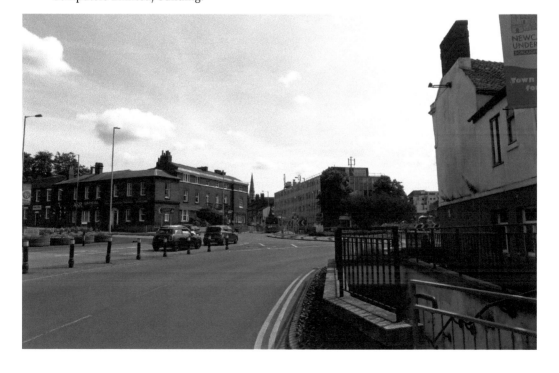

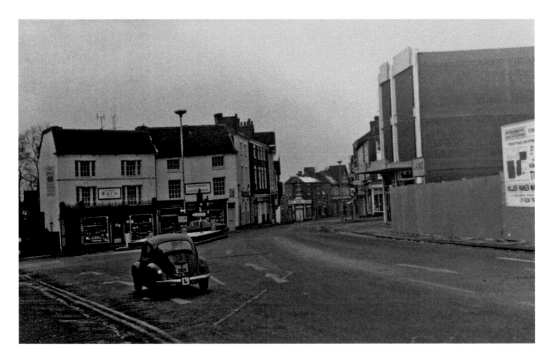

Red Lion Square, Newcastle, 1972 and Same View, 2022

William Frederick Rimmel was a churchwarden at St Giles' Church from 1872 until his death in 1914, aged seventy-eight. He operated a grocery shop that from the 1890s became occupied by Clement Wain, chemist. Wain's later opened a photographic shop next door. Major redevelopment on the south-west side of the street saw new shops being built. They would be occupied by such as Bookland, Craddock's, Blood Lloyd, Cartwright and Co. (jewellers) and Martin's the cleaners.

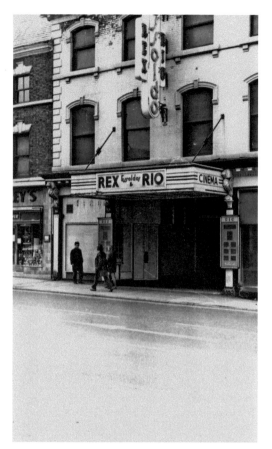

Rex and Rio Cinemas, Newcastle, 1972 and Lloyds Bank, Newcastle, 2022

The Rex and Rio in High Street were controlled by the Essoldo chain from 1954 and later by Classic Films Limited. To the immediate left was another Newcastle landmark – Blockley's Café Lounge. The Rio closed in October of 1971, suffering from structural problems. The Rex reopened in August 1972 and traded for around another year. Former manager for thirty years John Hudson died in 1986, aged eighty-seven. The Warner Village Cinema in High Street opened in September 2000, hastening the closure of the much-loved ABC Cinema in Hanley in December of that year.

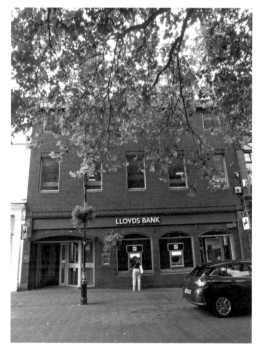

Fire Station, King Street, Newcastle, 1973 and Similar View, 2022

The one-time primitive nature of firefighting provision in Newcastle is illustrated by the fact that in 1623 every capital burgess in the town was required to provide himself with a leather bucket and every alderman with a hook and bucket. The use of thatch as a roofing material made the town particularly vulnerable to fires. The Borough Museum displays a Newsham engine of *c.* 1740 – the town's first manual fire pump. The town's fire station is now in Knutton Road.

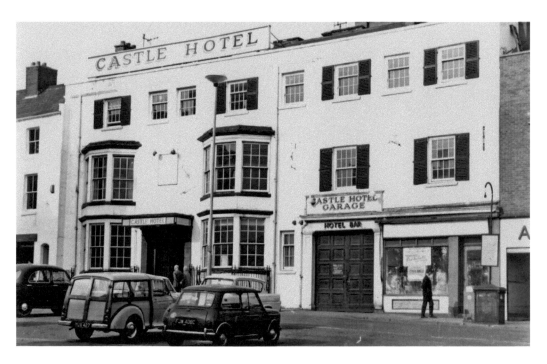

Castle Hotel, Newcastle, 1969 and Sense Charity Shop, 2022

This early nineteenth-century coaching inn and social hub of Newcastle advertised regular dance nights in the 1930s and 1940s with jazz proving very popular at that time. It closed in 1968, its façade – though altered – being retained and a Tesco supermarket subsequently trading on the site. Newcastle Civic Society's campaign to save the whole building failed, but the preservation of the frontage was important in retaining an architectural symmetry with adjacent buildings.

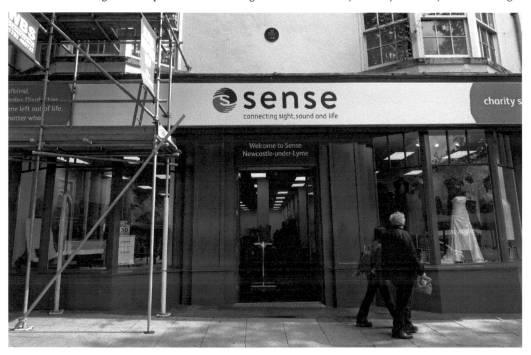

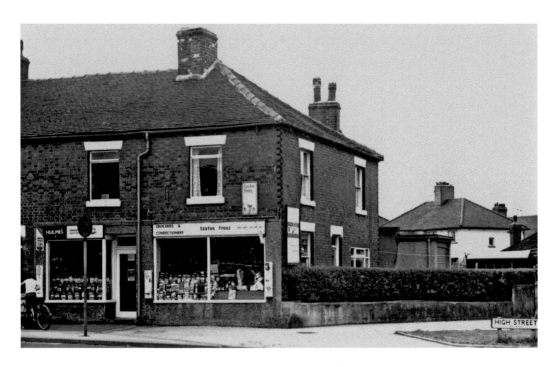

Hulme's Shop, High Street, May Bank, 1960s and She Devil, High Street, May Bank, 2022
Here is the junction of May Bank High Street and Alexandra Road – which became a busy spot from around the year 1900 when the Potteries Electric Traction Company established a depot in Lunt Street (now Wayside Avenue). The trams turned into Alexandra Road and then joined the arterial line on High Street. Within living memory, some May Bankers will recall this shop as the Chocolate Box in the 1980s.

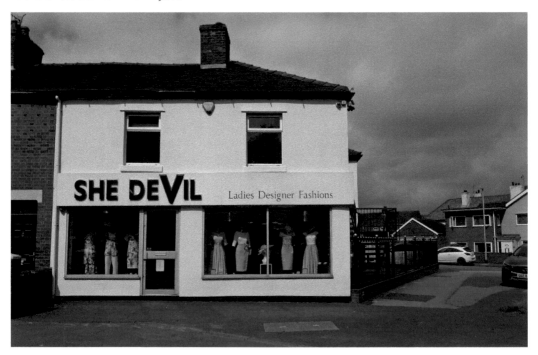

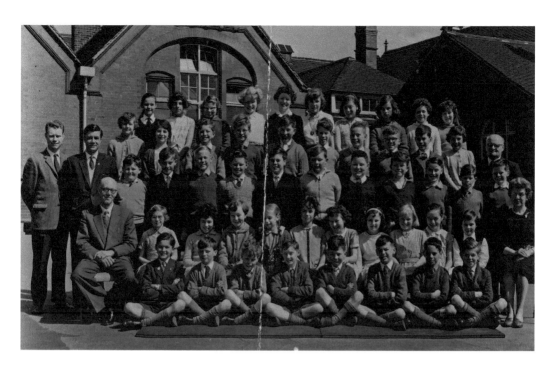

Ellison Street School, Wolstanton, 1962 and Ellison Primary Academy, Wolstanton, 2022
Teacher Mr Henry Gordon Landon, born 19 October 1908, is on the extreme right of the second row from the back. Many children of a certain generation remember his talent with the cane. The school logbooks record that in the 1960s there were school or class visits to Llandudno, Central London, H and R Johnson's Highgate Tileworks in Tunstall and to the Victoria Theatre in Hartshill to see the pantomime *Dick Whittington*. Children also took swimming lessons at the baths at nearby Hempstalls.

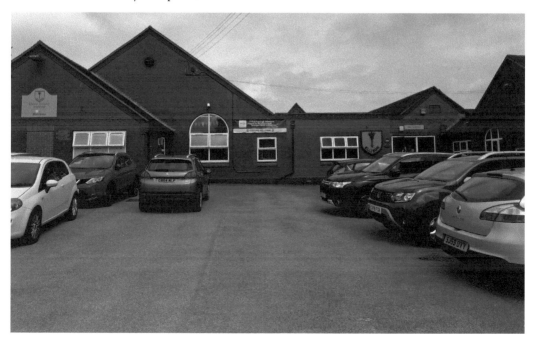

Marshlands Picture Hall, Church Lane, Wolstanton, 1967 and Car Park, Church Lane, 2022
The Marshlands Picture Hall – known variously as the House of High Class Pictures and the 'Bug Hut' – operated between 1911 and 1960 but the building survived for a few years after closure. The minutes of Borough Council meetings record that an application by E. J. Beech for conversion into a car showroom was refused in 1965 on account of the site's greater suitability for residential development. The site now forms part of the car park belonging to St Wulstan's Roman Catholic Church.

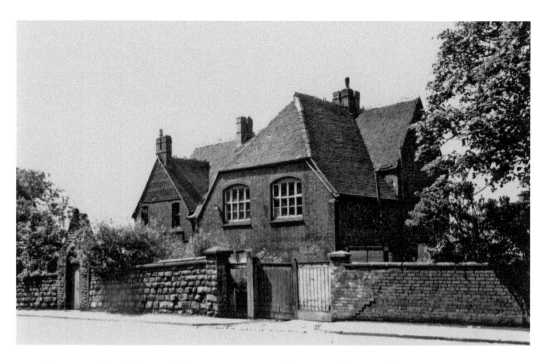

Vicarage, Church Lane, Wolstanton, 1970s and Former Vicarage Site, 2022
The old vicarage attached to St Margaret's Church in Wolstanton has been replaced by a few bungalows, though the stone wall and gate in front of it remain in situ. The gate shows the crossed keys – the symbol of St Peter – in its arch. Around the time the old photograph was taken, the annual crowning of the St Margaret's Church May Queen would take place in the vicarage grounds.

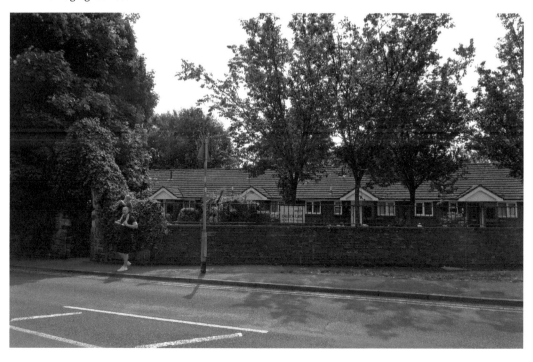

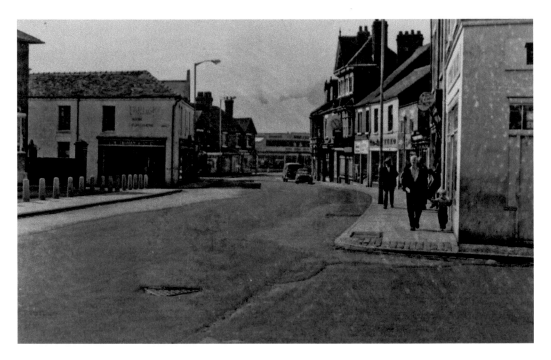

High Street, Wolstanton, 1967 and 2022

Wolstanton WMC on the far left now trades under the name of Wolstanton High Street Club. Truman's house furnishers traded in the village for decades, before closing in March 1995 on account of a sharp rise in business rates. Its last owner was Tony Fitchford. In the distance can be seen the Maiden and Ellis garage at the top of Silverdale Road. Various adverts in the local press advertised its Bedford TK vans (1960), its Vauxhalls (1963) and its Vivas, Victors, Crestas and Viscounts (1966).

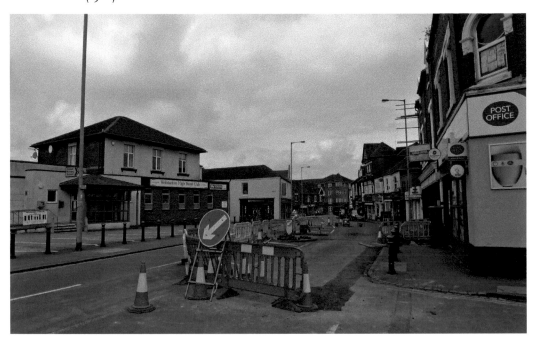

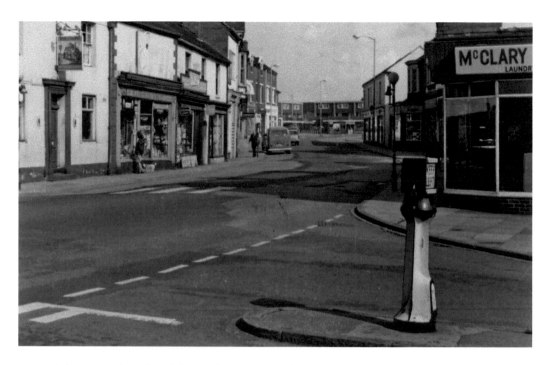

High Street with Silverdale Road Junction, Wolstanton, 1967 and Same, 2022
The Village Tavern (extreme left) was originally a beerhouse. It held a Yard of Ale drinking contest in September 1971 in which the previous record of 26 seconds was beaten – twice – by customer Maurice Winne, who recorded 18 seconds. The licensee at the time was Jim Radcliffe. Knowles' hardware shop was trading as Wolstanton Hardware up until its final day of opening on May 21 2022 and is a much-missed community shop.

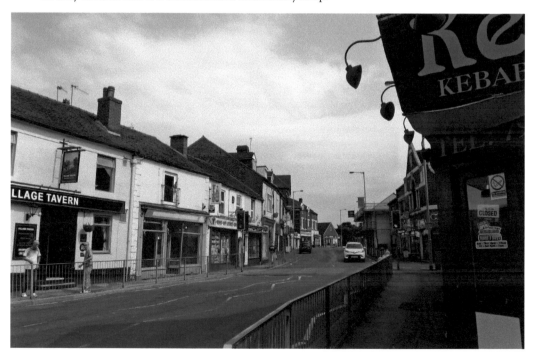

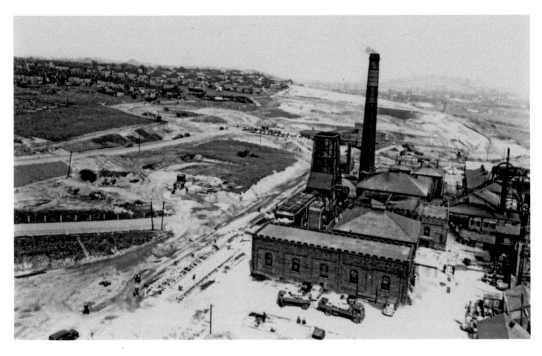

Wolstanton Colliery, 1959 and Dunelm, Wolstanton Retail Park, 2022
At the time of Nationalisation of the Coal Industry in 1947, Wolstanton Colliery had 650 men working underground and 215 on the surface. Most of the area above Wolstanton Colliery in this picture has now been redeveloped for housing whilst the pit site itself was shortly to be totally modernised. Among the shops on the present retail park are Marks and Spencer, opened 2014, and the homeware store Dunelm, which opened on Monday 12 April 2021.

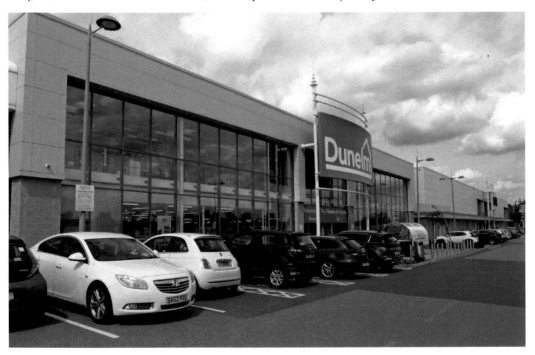

Wolstanton Colliery before
Reconstruction, date unknown and
Part of Wolstanton Retail Park, 2022
The story of Wolstanton Colliery
from 1970 embraces industrial unrest,
unofficial strikes and of course, the
Miners' Strike of 1984–5. Miners'
leader Arthur Scargill declared in
public that Wolstanton was on the
NCB's hit-list in late 1982 – only for
this to be denied. It duly closed in
1985. Two young schoolchildren,
Stephen and David Marshall – who
had lost their mother in a car accident
– were guests of honour in the almost
ceremonial blowing up of the colliery
towers. Hundreds of people watched
the reinforced concrete legs being
blown from beneath the towers. Our
2022 picture shows the pit wheel
motif at the lower end of the retail
park, reminding us of the site's
previous history.

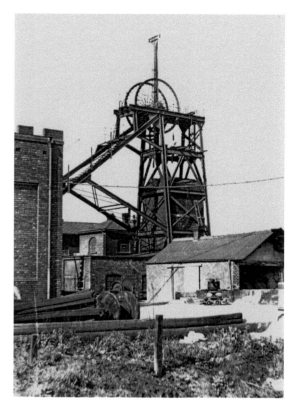

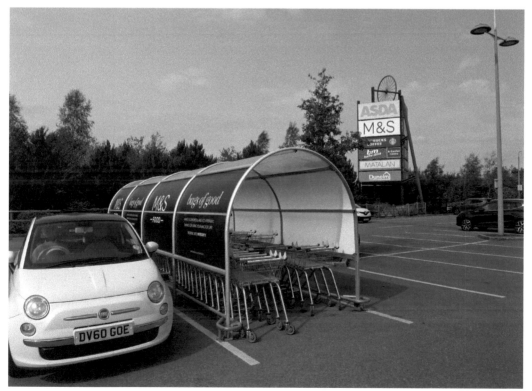

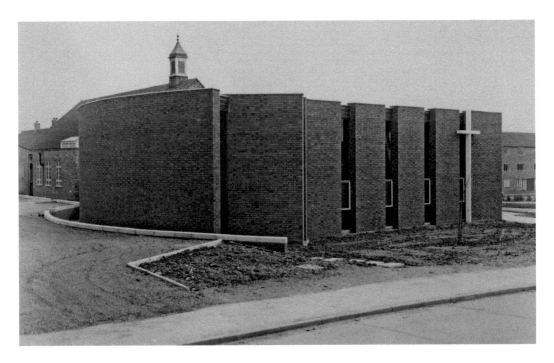

Methodist Church, Bradwell, date unknown and 2022
Just before the Second World War, Newcastle Borough Council began to develop the Bradwell Hall Farm estate as a municipal housing area. Only a few houses were erected before war broke out, but with the end of hostilities, the housing estate grew and its new Methodist church was opened in February 1950 for the accommodation of Bradwell and Dimsdale residents. The opening of Bradwell WMC further along Bradwell Lane, in November 1955, marked another local social advancement.

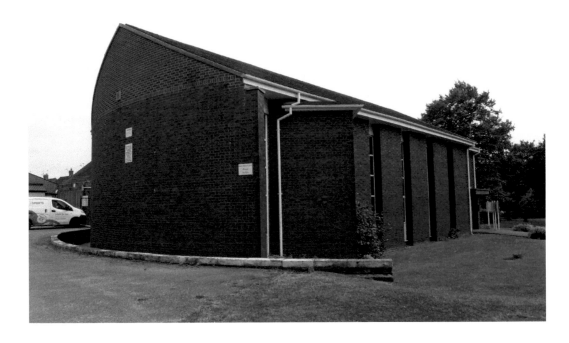

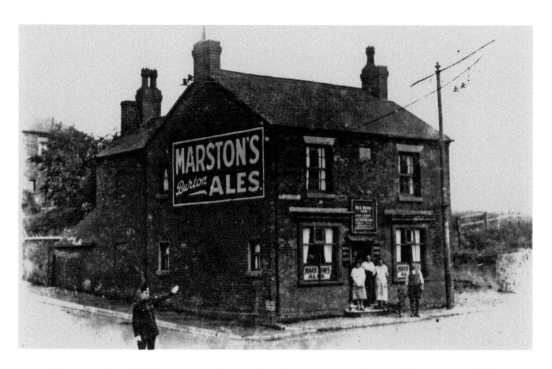

Milehouse Pub, Milehouse, near Newcastle, date unknown, Present Site, 2022 and Milehouse Restaurant, 2022

The original Milehouse Inn beerhouse of 1813 stood on the opposite side of the road by what was sometimes referred to in the local press as the Milehouse Inn crossroads. It was known for its long hours, namely 5.30 a.m. to 11 p.m. Early morning calls were paid by carters, on the way to Sandbach to fetch packing straw for potters. The new pub, built in 1932, has been known in more recent years as the Berni Tavern and Buffet Island.

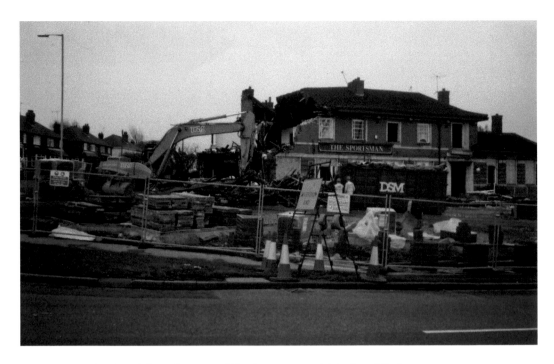

Sportsman Pub, Dimsdale, Being Demolished, c. 1999 and Macdonald's Restaurant, 2022
The original Dimsdale Hotel stood on the south corner of Dimsdale Parade. During its
construction in 1937, a motorist on the way to Newcastle collided with a builder's sign on the
site. The car overturned but no party was injured. It was opened by Ind Coope and Allsopp in
February 1938. The hotel's cellars were so large that Dimsdale FC used to change in them. It later
became known as the Lymelite and from April 1992, the Sportsman.

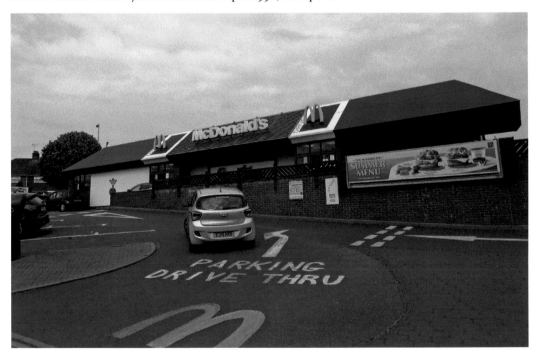

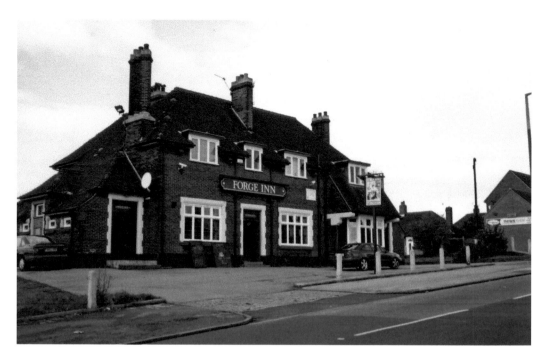

Forge Inn, Knutton, *c.* 2002 and Forge Inn, Former Site, 2022
The Forge was at one time reputed to be haunted by an ex-landlord called Billy Harley. It was being run by Burtonwood Brewery certainly by the 1980s. There was a football team attached and the pub had a reputation for pub skittles. In 2009, *The Sentinel* announced that work had begun on the demolition of the pub after being closed for two years. It is survived by the Mason's Arms, which still trades in High Street.

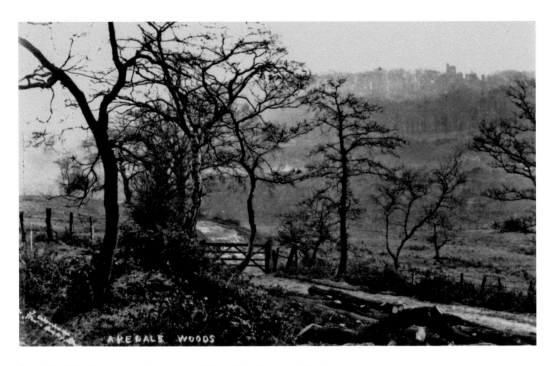

Apedale Woods, date unknown and Apedale Country Park, 2021
The Apedale Valley was formerly a prosperous hive of industry incorporating collieries, brickworks, ironworks, canals and railways developed by the Heathcote family of Apedale Hall. The blast furnaces began working by 1784. The chief coal-winding pit on the Apedale estate was the Burley Pit, dating from 1872. However, a depression in trade forced the closure of operations at Apedale and nearby Podmore Hall in April 1930, thousands of men losing their jobs.

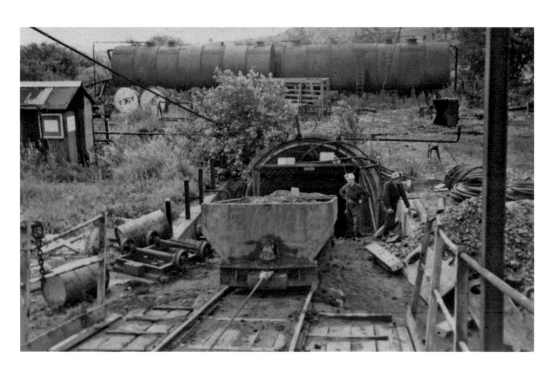

Apedale Colliery, near Chesterton, date unknown and Guides at Apedale Heritage Centre with Visitor Paula Brockley, 2021

Apedale's drift mine closed in 1998, having been run by Aurora Mining Limited. With nearby Silverdale Colliery expected to close (it did, in December) it was envisaged that water levels at Apedale would rise and that it would not be cost-effective to overhaul pumping operations. With the opening of Apedale Heritage Centre in 2001, visitors were able to explore the old pit workings. Its chairman, Keith Meeson, donated many artefacts that are now stored in the adjacent exhibition hall.

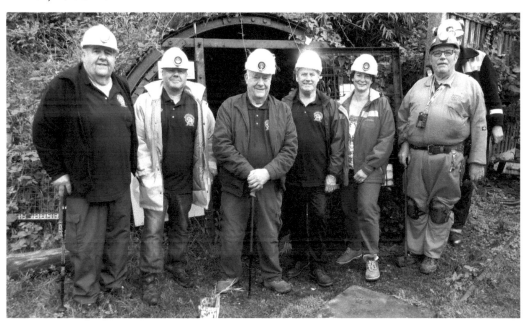

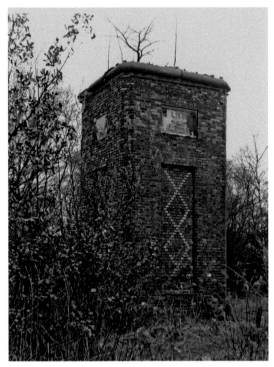

Watermills Colliery Chimney, date unknown and 2011
Nestling within Apedale Country Park is the remaining stump of a 186-foot-high ventilation chimney that had been built in 1840 to serve the Watermills Colliery. The structure embraces red brick with decoration in yellow and blue brick. Mottoes on it read Regard The End, Be Honest and Fear Not and Live and Let Live. Also visible are the initials REH standing for Richard Edensor Heathcote, colliery owner. The Watermills Colliery closed in 1912. The chimney remains were Grade II listed in 1991.

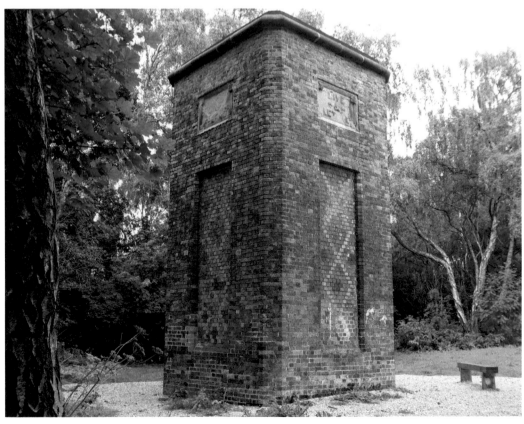

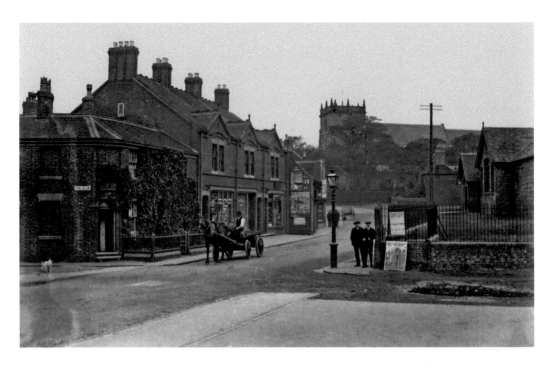

Dean Hollow at Junction with Church Street, Audley, date unknown and Same View, 2022
St James the Great Church in Audley dates from the thirteenth century but was partially rebuilt in the 1840s by George Gilbert Scott. Charles Philip Wilbraham had been appointed vicar in 1844. His influential contacts included the nineteenth-century statesman William Ewart Gladstone who gave £10 towards the restoration fund of the church. He was an inveterate traveller. He gave a lecture entitled Recent Adventures in Egypt and India at Wolstanton National Schools in 1869, having just returned.

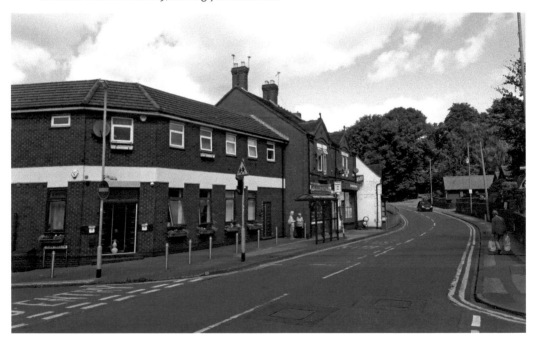

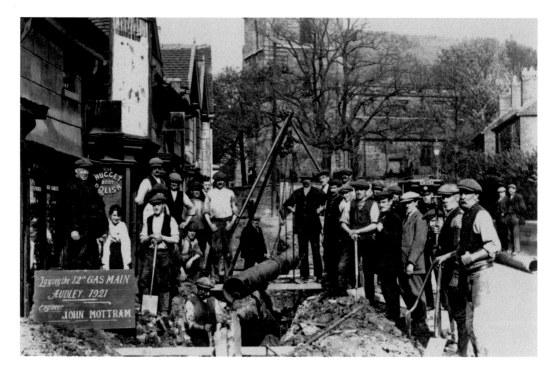

Church Street, Audley, Laying the 12th Gas Main, 1921 and Church Street, 2022
Another vicar, the Revd J. L. D. Lewis, wrote in the parish magazine of 1943 that he had been deemed of sufficient importance to come to the notice of gossip-mongers who had accused him of being late for a funeral. Evidently piqued, he stated, 'Gossip is not Christian; it crucified Christ. Christ hated it and we should hate it also.' The church, with its solid sandstone west tower, is Grade II* listed.

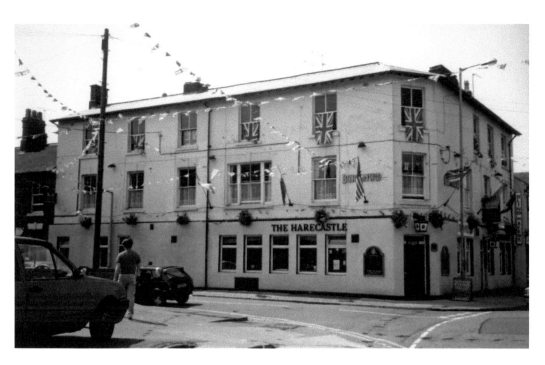

Harecastle Pub, Kidsgrove, 1995 and Railway Inn, Kidsgrove, 2017
The attractions of the Harecastle Hotel to tourists were advertised in the local press of July 1908 when it was advertised alongside hotels in Blackpool and the Isle of Man as being 'Ideal Summer Quarters, being on the borders of Cheshire, close to golf links and bowling greens and offering stabling and a motor garage'. In recent years, it became the Potter Tea tearoom before being renamed the Railway in acknowledgement of Kidsgrove station's proximity.

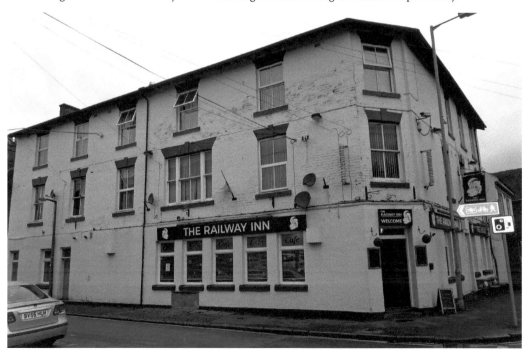

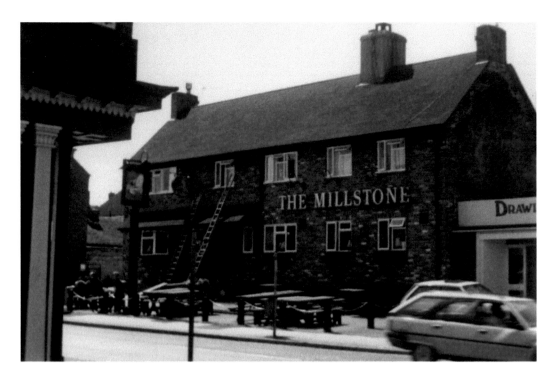

Millstone, 1990s and Former Millstone, 2022

The Millstone once had a bowling green and skittle alley. Local historian Philip Leese wrote in his volume on Butt Lane that the Millstone could be traced back to 1789 at latest. He added that a former publican was Solomon Bentley who was a member of the local Methodist choir. 'He had to endure many sermons warning of the evils of drink before returning to serve behind the bar.' The pub changed its name to the Healing Well around 2013 before ultimately closing.

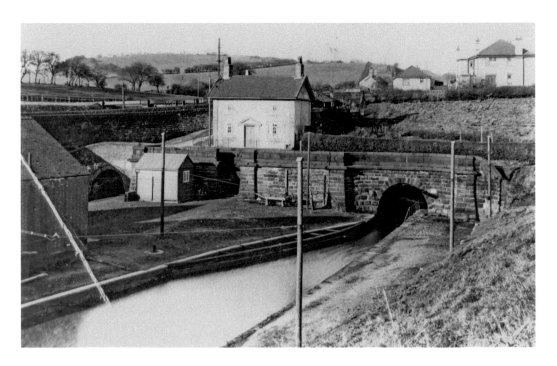

Harecastle Tunnels, Kidsgrove, 1935 and Similar View, 2020

The Brindley (left) and Telford (right) canal tunnels at Harecastle were completed in 1777 and 1827 respectively. Brindley'sl had no towing path, so boats had to be 'legged' through whilst boat-horses took a rest. By 1913 it was described as 'simply a narrow hole, or what they would today describe as a big drain, just wide enough to pass a boat through'. It was closed in 1914, having suffered from subsidence. Telford's tunnel was much wider and incorporated a towing path for horses.

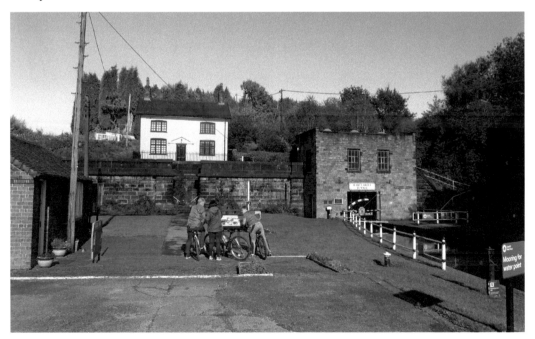

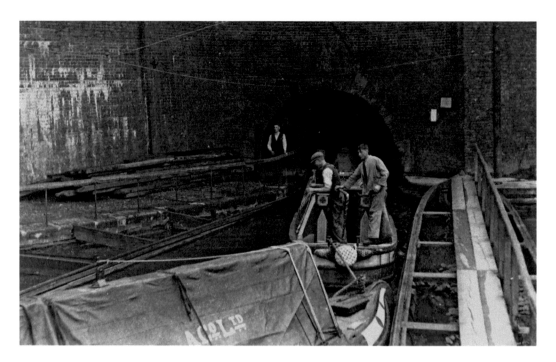

Harecastle Tunnel Boats at Kidsgrove End, 1930s and 2016
Brindley's tunnel is now gated at both portals and inaccessible to boats. Inside Telford's tunnel are indications of the old internal canals that connected the Goldenhill Colliery workings with the Trent and Mersey, accelerating the coal's journey from coalface to local markets. Telford's tunnel is used by pleasure boat traffic today. Strong fans ensure that fresh air is drawn through the tunnel, protecting boaters from the harmful build-up of diesel fumes. The orange colour of the water in these parts is caused by iron ore leaching into the canal.

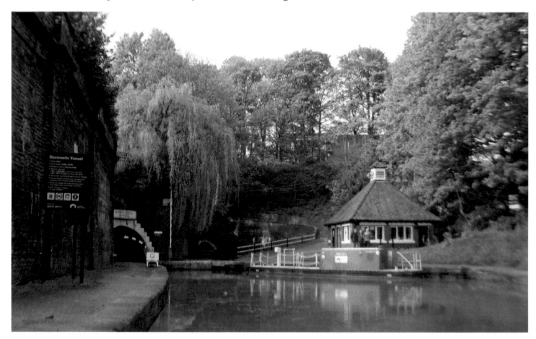

Swan, Silverdale, Interior, probably 1960s and Swan Approximate Site, Mill Street, 2022
The Swan had a strong connection with Potteries chanteuse Gertie Gitana. Her mother Lavinia's second husband was Bob Burdon – the landlord of the Swan. Landlady Lavinia died of pneumonia in 1933 and was interred in Burslem Cemetery.

Amos Ball is shown on the left of the photograph. He was born in Mount Skip, Chesterton, in 1907 according to his granddaughter Julie Bagnall. He lived with his wife in Rosemary Street (formerly Rosemary Buildings, where Garner's now stands) at this time. The lady on the right is thought to have been a Mrs Bostock who lived in one of the semi-detached houses opposite the Swan.

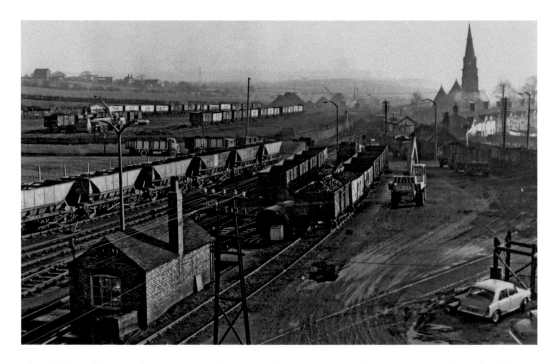

Silverdale Colliery Sidings, date unknown and Greenway and Approximate Site of Old Sidings, 2022

The Silverdale Company was formed in 1792 in order to dig for ironstone but coal was mined from around 1830. The only major recorded disaster at Silverdale came in 1870 when nineteen men were killed in an underground gas explosion. A book, *Most Splendid of Men* (1981), by Harold Brown described the author's life as a miner between 1917–25 and remains one of the best working-class autobiographies written by a North Staffordshire man.

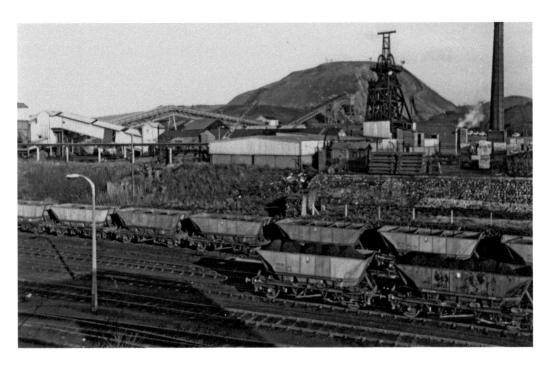

Silverdale Colliery, date unknown and Pit Tub outside St Luke's Church, Silverdale, 2022
The miners at Silverdale Colliery – once known as Kent's Lane – enjoyed darts, football and angling, arranged under the auspices of the Coal Industry Social Welfare Organisation. The pit closed in December 1998, meaning that coal had been worked underground for the last time in Staffordshire. Housing and a country park have now been established on the former colliery site, but Silverdale has been keen to acknowledge its mining past, as we see from the bottom photograph.

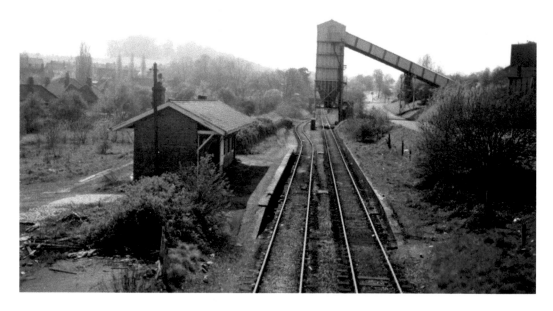

Disused Railway Station, Silverdale, 1991 and Rebuilt Silverdale Railway Station, 2016
In the distance (top photograph) is the rapid loading bunker at Silverdale Colliery. Silverdale's first railway station (1862–70) was replaced by this one, which operated from 1870 until becoming a victim of the Beeching cuts in 1964. However, it was not taken down until 1998. Afterwards, it was reassembled, using some of the original materials, to form an eye-catching focal point at Apedale Heritage Centre. A model of the station is displayed in the museum's exhibition hall.

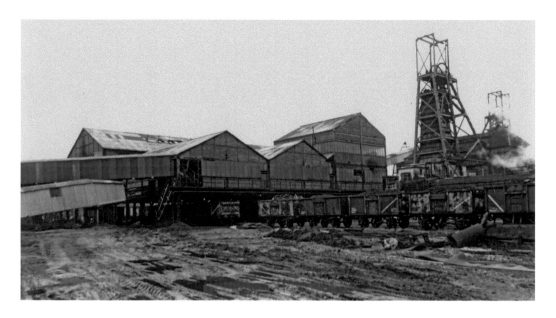

Holditch Colliery, the Old Washery, 1972 and Holditch Colliery Gates and Jim Worgan, 2021
Holditch Colliery was sunk from around 1912 by the Wrexham-based Brymbo Steel Company and closed in 1989. It had a reputation for being one of the gassiest pits in Britain. The mining disaster that occurred there on 2 July 1937 took the lives of thirty men, with eight being injured. This tragedy is commemorated every year – more recently at Apedale Heritage Centre – with mining historian Mr Worgan often delivering a short speech on the pit's darkest hour.

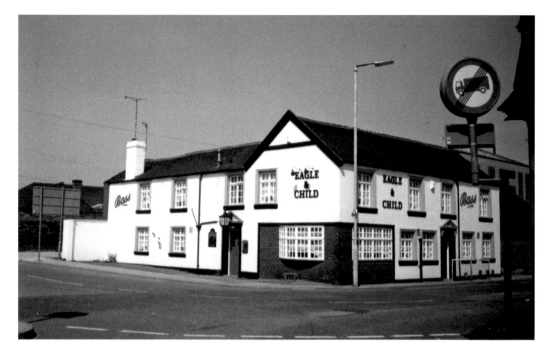

Eagle and Child, Chesterton, 1991 and 2022

This pub stood on the corner of Apedale Road and Audley Road and by 1860, the Blue Tilers' Refuge friendly society was meeting there – illustrating Chesterton's strong links with brick and tile making. When Roy and Sue White took on the Eagle and Child in January 1990, they introduced braille menus for the blind, in an effort to accommodate the disadvantaged. Sue was studying sign language at college at the time, and could communicate with deaf customers. The pub was demolished in May 2017.

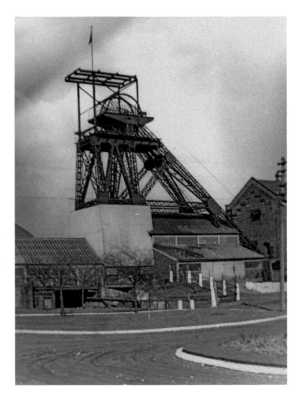

Parkhouse Colliery, near Chesterton, date unknown and Former Site, 2022
This colliery dated from 1874. The original tandem pits were operated by J. H. Pearson of Handsworth, Birmingham. No. 3 shaft was sunk in 1917. Geographically, it was a short distance from Chesterton's New Hem Heath Colliery. Pithead baths were opened on site in 1940 under the auspices of the National Miners' Welfare Commission. Located just off the A34 near Chesterton, it closed in 1968, with the site later accommodating the Parkhouse Industrial Estate.

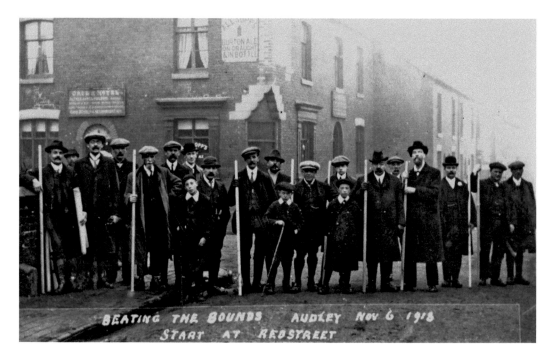

Red Street and Crown Pub, 1918 and Same View, 2022

Beating the bounds of a parish was sometimes known as perambulation. Vestry committees were charged with the responsibility of walking their parish boundaries, checking that boundary markers were still in situ and that no new (and unrated) buildings had been erected without permission. Children regularly attended the perambulation, which in later times became a custom rather than a necessity. The Crown is listed in the 1818 trade directory and its present address is Talke Road.

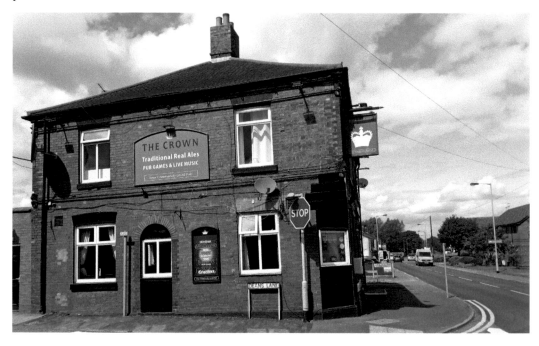

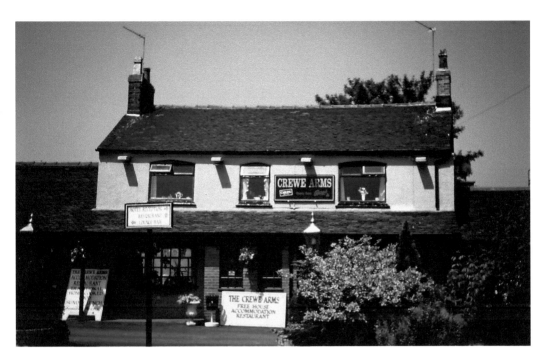

Crewe Arms, Wharf Terrace, Madeley Heath, 1995 and Same View, 2022
The Crewe Arms beerhouse originally stood next to Madeley main line station in nearby Station Road. When landlord Michael Hopwood, who had lived at the house for ten years, applied for a wine and spirit licence in 1877, he told the magistrates that when accidents occurred at nearby Leycett Colliery, he was often asked for spirits. In the same year, a coroner's inquest relating to George Wagstaff, who had perished in a roof fall at the Harrison and Woodburne pit, took place at the Crewe Arms.

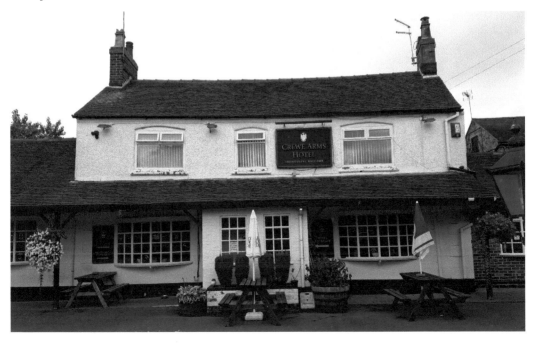

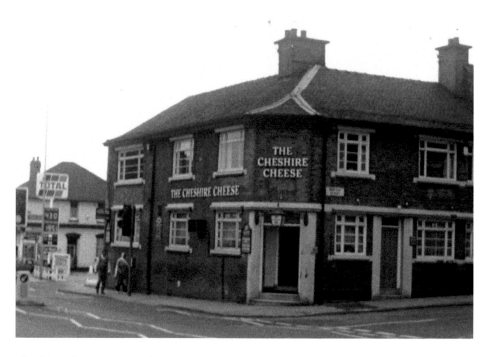

Cheshire Cheese Pub, High Street, Tunstall, 1990s and Cheshire Cheese, 2022
This pub is not to be confused with another Cheshire Cheese that stood in King Street. According to CAMRA sources, this one was built in 1889, and certainly advertised for a general servant in that year. It was formerly a Parker's Burslem Brewery pub and was once popular with pottery workers. *The Sentinel* reported in September 2012 that the two-roomed pub had been sold for £60,000 at auction after closing in that year with a view to the site being turned into flats.

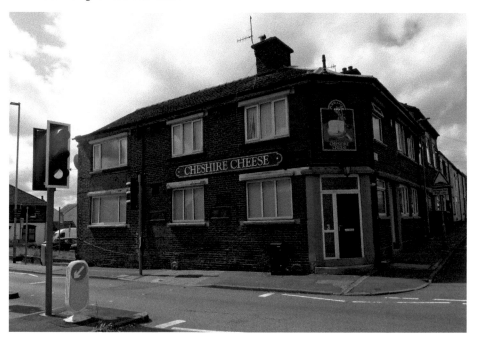

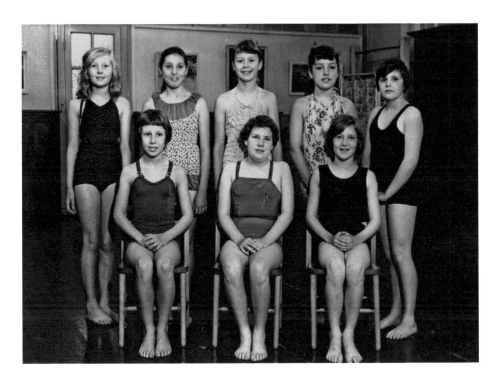

Summer Bank Primary School, Summerbank Road, Tunstall, Girls' Swimming Team, 1959 and Summer Bank Primary Academy, 2022

This seat of learning was opened by Tunstall Education Committee as Summerbank Council School on 15 July 1909 and designed by the prolific architects A. R. Wood and Son, of Tunstall. It was reported that 'the rooms are simply flooded with daylight by means of the liberal window-space'. This was a feature of Wood's buildings – see the Jubilee Buildings in Tunstall. The girl on the extreme right of the swimming group is Mary Roberts, now better known as local author Mary Mae Lewis.

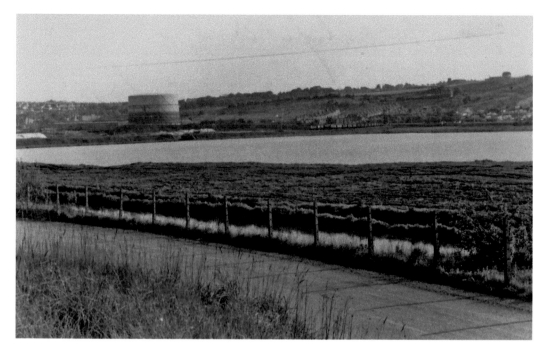

Westport Lake, Tunstall, 1967 and 2022

On 1 October 1971, Westport Lake water park was opened by the then Prime Minister, Edward Heath, as the city's latest reclamation scheme. However, its origins as a potters' playground can be traced to around 1890 when local farmer Smith Shirley advertised various entertainments around the lake. At different times, these included rowing, swimming galas, polo matches, wrestling contests on a raft, footraces around the lake and skating in the winter months. Smith Shirley died in 1925.

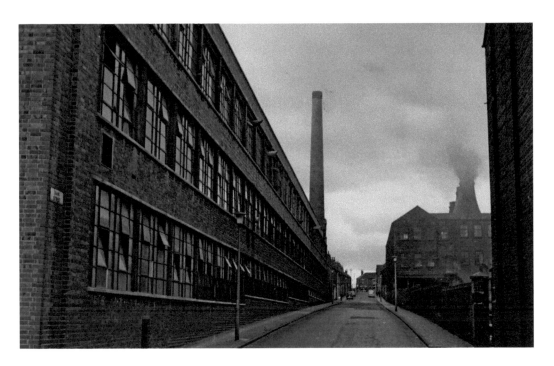

Bank Street (looking up), Tunstall, 1966 and Bank Street, Upper, 2022

Bank Street appears on the OS map of 1877 and a Bank Street chapel is certainly mentioned by 1870. The prominence of Tunstall as a ceramic centre is indicated in the monochrome photograph, though much demolition has taken place since. The lower part of Bank Street has been transformed by new housing, so the bottom picture is intended to show some of the elements that have survived. A stroll around the area will reveal the old 'backs' behind properties.

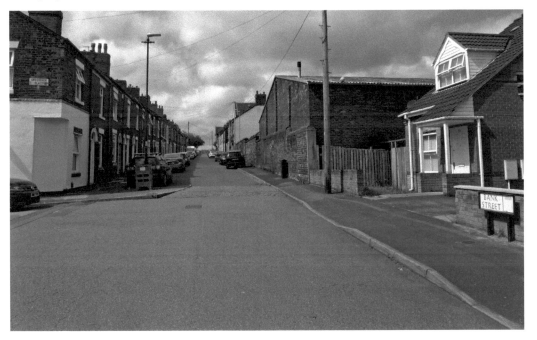

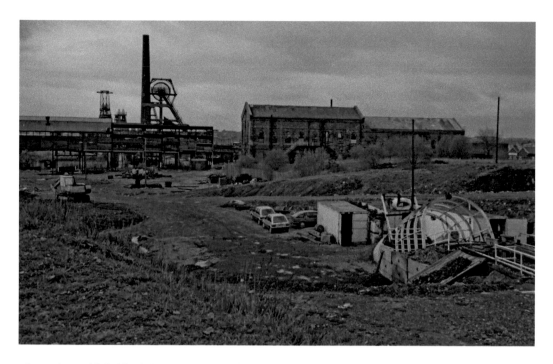

Chatterley Whitfield Mining Museum and Drift Mine to rear, date unknown and Chatterley
Whitfield and Hesketh Heapstead, 2022

Whitfield Colliery – later Chatterley Whitfield – was one of the driving forces of the Industrial
Revolution in the Potteries. The colliery closed in 1977 becoming a popular mining museum
between 1979 and 1993. The drift mine in the top photograph was opened by Roy Price of the
R. P. Minesearch company. The focal point of both pictures is the Hesketh shaft headgear. The
shaft was 640 yards in depth and was the chief coal-drawing shaft on site.

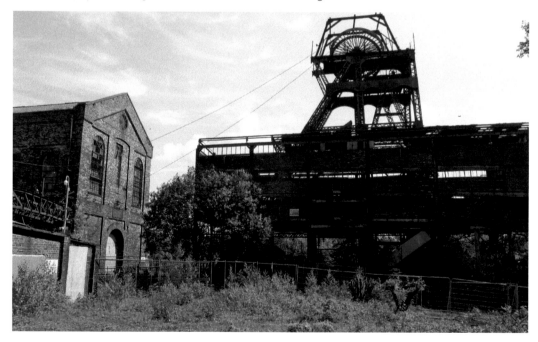

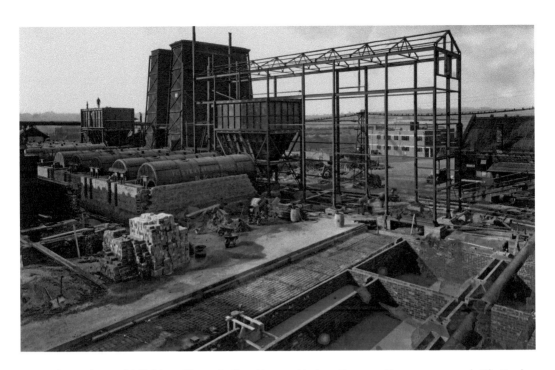

Chatterley Whitfield Colliery Boiler House Under Construction, 1930s and Chatterley Whitfield Site, 2019

Whitfield's boiler house is seen in construction in the late 1930s. It would eventually contain ten Lancashire boilers, which would be fuelled by pulverised coal and was one of the best boiler houses in the country. The boiler house and surrounding buildings are now in a dreadful state of repair. In the background of the top photograph we see the site's main offices, built in 1934 to accommodate management and staff who moved from Tunstall.

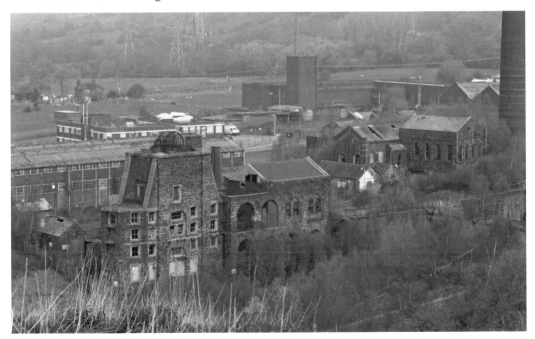

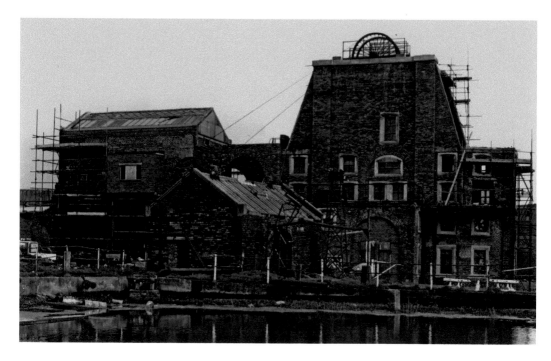

Winstanley Shaft Headgear, Chatterley Whitfield, date unknown and Winstanley Shaft, 2022
November 1912 saw an explosion in the site's Middle Pit which suggested that ventilation needed to be improved. This was the chief reason for building the Winstanley shaft in 1913/4, named after the company's engineer, Robert Winstanley. It was built to a German design with headgears enclosed by brickwork and was never used for coal-drawing. This was the shaft that museum visitors used to access the underground, prior to the creation of the so-called New Pit, based around the Platt shaft in 1987.

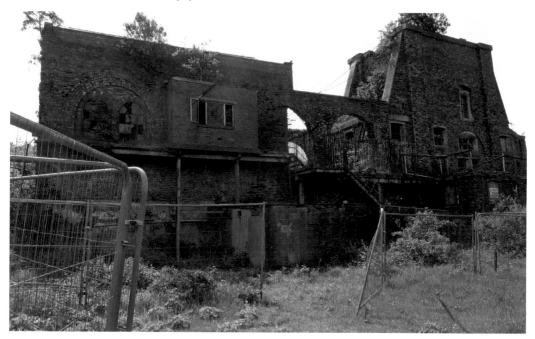

Chatterley Whitfield Mining Museum, Ben the Shire Horse with Young Volunteer, 1990 and Friends of Chatterley Whitfield, 2022

Ben was a star attraction at the museum and often pulled a dray at Biddulph Carnival. Former pit ponies including Blackie, Darkie, Glen and Medie were stabled at Whitfield overnight. Educational roadshows presented by staff – accompanied by one of the pit ponies – were taken out to various local schools. The decaying site is presently in the care of Stoke-on-Trent City Council and the Chatterley Whitfield Friends group whose sterling efforts help to preserve and promote what is left of this historic site.

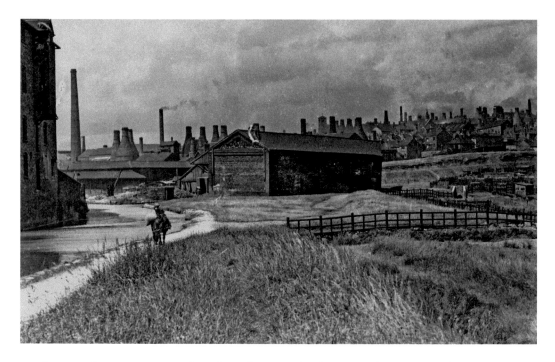

Burslem Canal Arm, 1930s, Junction of Burslem Canal and Trent and Mersey Canal, 2022 and Interpretation Denoting Site of Burslem Canal Arm, 2022

The old Burslem Branch Canal was a three-quarters-of-a-mile arm of the Trent and Mersey Canal and was linked to the town centre by a tramway that followed the incline of Navigation Road. Authorized by an Act of Parliament in 1797, it opened in 1805. It closed in 1961 when it was breached. The expected cost of repairs led to its abandonment in 1962. The Burslem Port Project seeks to restore the canal and to provide ambient leisure facilities for boaters and other visitors.

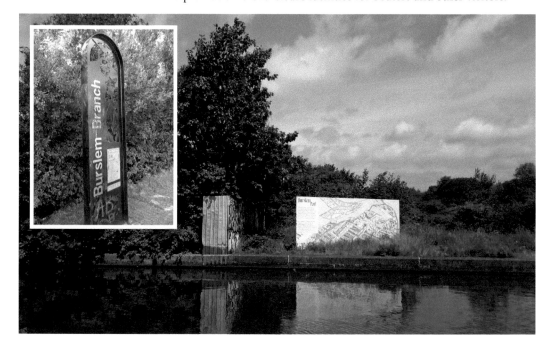

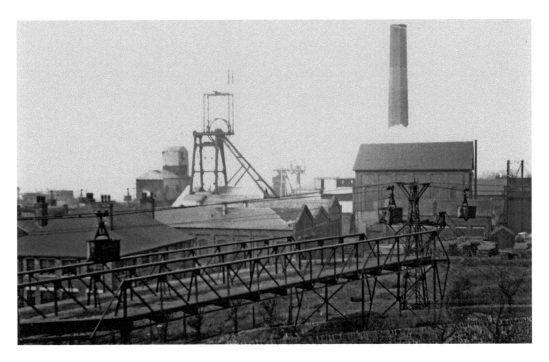

Sneyd Colliery, Burslem, 1950 and Sneyd Hill Park, 2022
This colliery was located between Burslem and Smallthorne and had a brickworks attached. It is a little-known fact that in 1911, Potteries author Arnold Bennett descended the No. 4 shaft at Sneyd Pit, which he described as 'a model pit – conditions appalling'. He added that luxury was increasing everywhere and that the masters had 'powerful and luxurious motor-cars, and splendid residences in unspoilt rural surroundings. The miners had the latest appliances for saving their lives.'

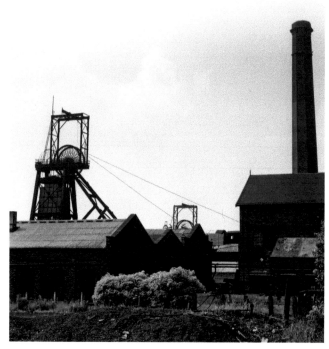

Sneyd Colliery, Burslem, date unknown and Sneyd Hill Park from Burslem Cemetery, 2022

The Sneyd Colliery disaster of 1942 took the lives of fifty-seven men and boys. As part of a major reconstruction at Wolstanton Colliery, an underground connection was made with Sneyd Colliery. Winding ceased there in July 1962, with Wolstanton becoming the focus for coal-drawing. One of the shafts at Sneyd remained in use in order to lower maintenance workers into the workings and also for ventilation. The site of the colliery later became the Sneyd Industrial Estate.

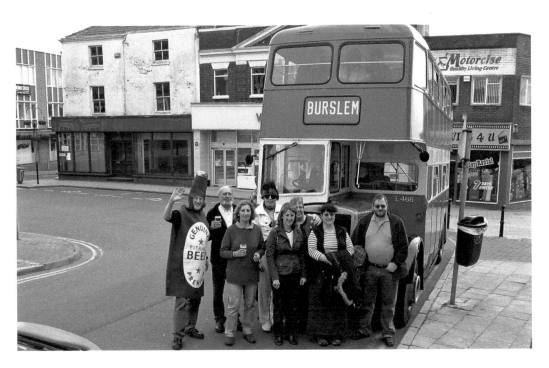

St John's Square, Burslem and Drinkers, 2007 and 2022
Members of the Potteries Pub Preservation Group and the Potteries branch of CAMRA enjoy a pub crawl with a difference. Author Mervyn Edwards is dressed in a beer bottle costume. A famous retail name of the past can just be discerned behind the bus. The Burslem branch of F. W. Woolworth and Company Limited opened on 6 September 1929 and – naturally enough for the Mother Town – sold several china and pottery articles sourced from local manufactories. The store closed in 2008.

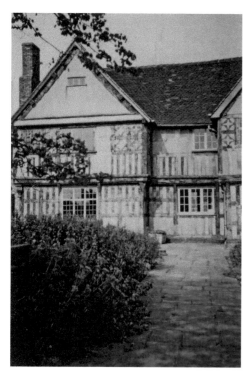

Ford Green Hall, Ford Green, 1958 and 2022
The Ford family was settled in this area by the thirteenth century, becoming active in farming and coal mining. This is a Stuart building, dated around 1624 with a brick wing of 1734. Industry in the form of coal and ironstone working altered the local landscape significantly and the Ford family papers recorded in 1865 that 'Ford Green is now black with coal pits and part of the old house is let out to miners at 2/6d per week.' It is now a successful folk museum.

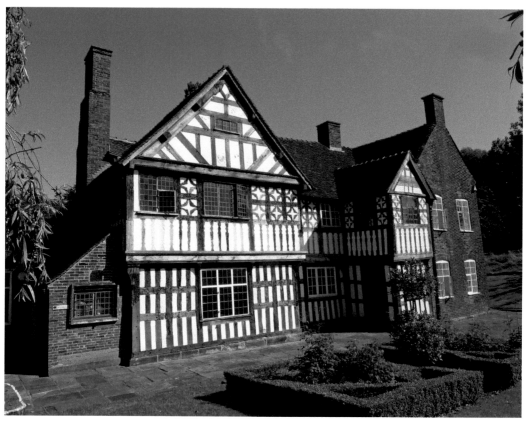

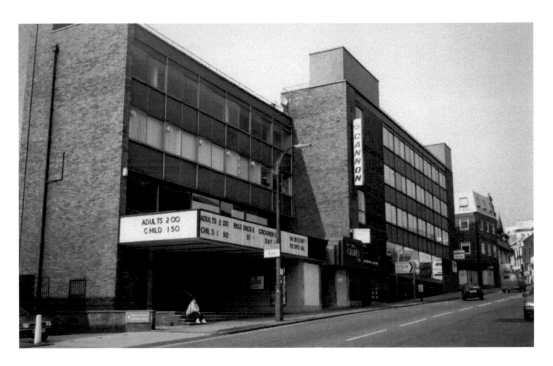

Cannon Cinema, Hanley, 1993 and Tesco Supermarket Entrance, 2022
The ABC Cinebowl opened in August 1963 as a brand-new multiplex entertainment venue, offering films and ten-pin bowling. The first film to be shown was *The Cracksman* featuring Charlie Drake. The venue struggled to survive following the opening of the Odeon multiplex at nearby Festival Park in 1989. In its later life, it was converted into a casino. Owners Odeon closed it in December 2000 and the building was demolished in February 2008, ultimately making way for a supermarket.

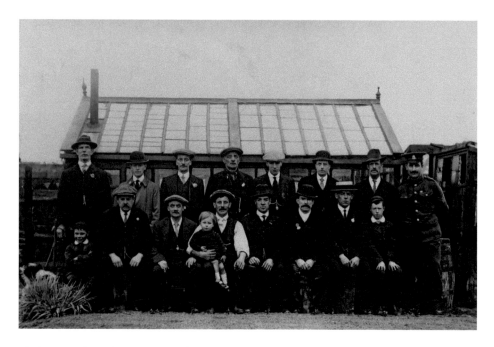

Birches Head Gardeners Original Committee, *c.* 1918 and Birches Head Gardeners Club, Oak Street, Birches Head, 2017

These men are very likely to have been the founders of the original Birches Head Gardeners Club in Oak Street. They kept allotments nearby. Members once met in an ex-army hut from Lincolnshire that was re-erected on site. A soup kitchen operated from the club during the General Strike of 1926. The club had a bowling green to the rear, with matches continuing until the autumn of 2015, the club premises having been purchased by the Archdiocese of Birmingham.

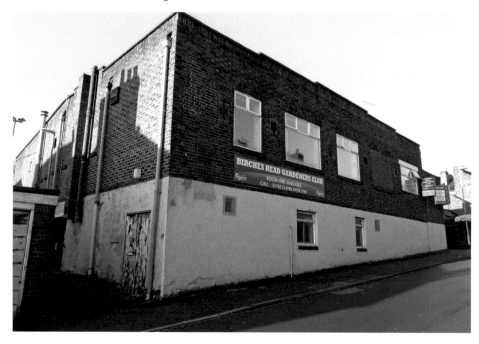

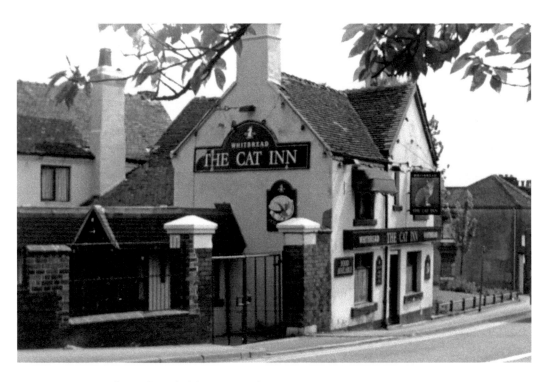

Cat Inn, Northwood, probably 1990s and 2022
In the nineteenth century, the Cat Inn stood adjacent to the Cat Fields, where plots of land were up for sale in 1866. At the opening of Northwood Park in 1907, Alderman Ellis reminisced about Northwood's progress, recalling that within living memory, the cat on its pictorial sign 'was so much like a leopard, that the house was often called by that name'. In 1998, landlord Alex McEneaney's own cat, Pedi – named after Pedigree bitter – was depicted on a brand-new pub sign.

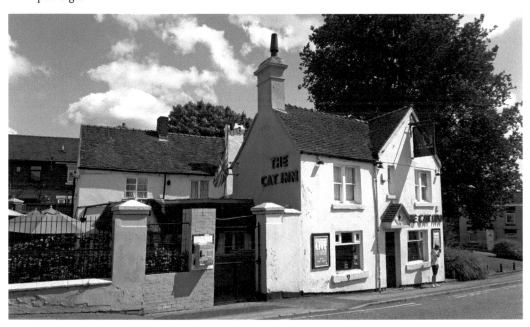

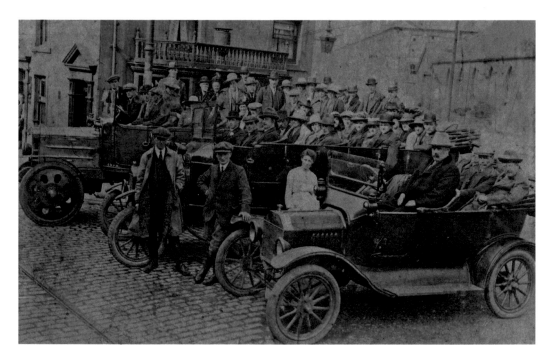

Denbigh Castle Hotel, Stoke, date unknown and Liverpool Road, 2022

Liverpool Road was built as 'the new road to Shelton' and at its junction with Shelton Old Road stood the Denbigh Castle Hotel. It was a stop on the main bus route through the Potteries. It was used for meetings of the Stoke and District Canine Society in the early twentieth century and enjoyed a reputation for pub skittles in the 1930s/40s. It stood opposite the Bridge Inn, but had other competition in Liverpool Road including the Star Inn and the Phoenix.

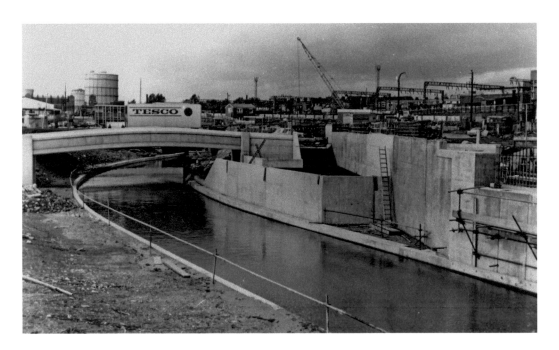

Stoke and Queensway/D Road Under Construction, 1973 and Queensway, running through Stoke, 2022

The A500 is known as the Potteries D Road, referencing its configuration. Its construction required the demolition of numerous properties in Stoke town. It officially opened in 1977, termed Queensway to mark the Queen's Silver Jubilee. It greatly improved local road communication but subsequently became a running joke on account of its tendency to bring the city to a halt through traffic congestion or an accident. In fairness, this expressway is forty-five years old and road traffic has increased since its opening.

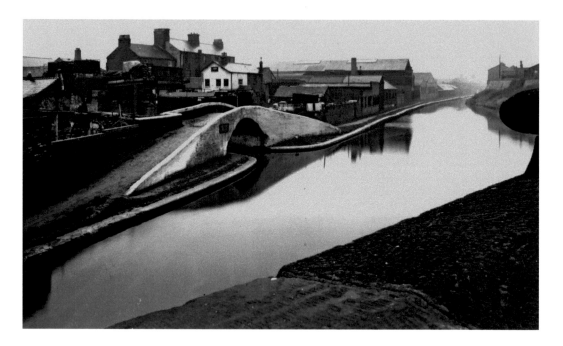

Stoke at the Junction of the Trent and Mersey Canal and the Newcastle Canal, 1960 and Newcastle Canal Junction Marker by Trent and Mersey Canal, Stoke, 2022
The Newcastle Canal, authorised in 1795, left the main canal at Stoke, passing through the town centre and along London Road prior to turning through Trent Vale and on to its terminus close to Brook Lane in Newcastle. In 1863, the canal was sold to the North Staffordshire Railway, which already owned the Trent and Mersey Canal. The headquarters of Stoke-on-Trent Boat Club (formed in 1957) were adjacent to the Newcastle Canal, the whole of which had been abandoned by 1935. Little of it remains today.

Basford Bank, *c.* 1970 and 2022

Etruria Road leads down to Basford roundabout on the A500, which was immortalised in Claybody Theatre's Potteries comedy *The D Road* written by Debbie McAndrew. Properties in Bank Terrace were demolished before the road's construction. The former Royal Doulton artist Anthony Forster's watercolour painting *Echoes of Etruria* famously depicted a Lamplighter on old Basford Bank with a view of the industrial Potteries in the background – bottle ovens, drifting smoke, louring spoil tips and all.

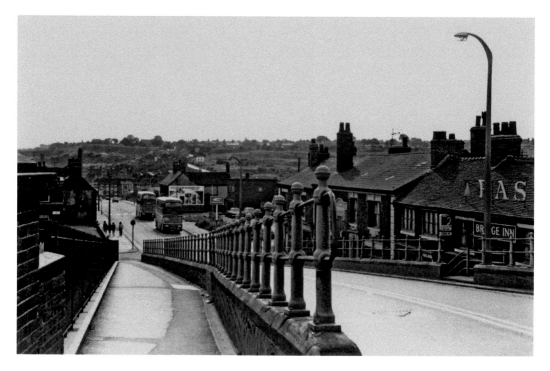

Bridge Inn, Etruria, 1969 and Bridge over Trent and Mersey Canal, 2022
The Bridge Inn was aptly named as it was situated immediately below the old canal bridge. In 1859, it hosted a dinner honouring nine of the oldest workmen of the Wedgwood factory – each having served over fifty years. Sentinel reader W. B. Gilbride recalled the pub's landlord in the 1970s, Colin Garnett, his assistant Harry, and their usual question at closing time: 'Have you got no homes to go to?' The pub was much favoured by musicians and folk singers.

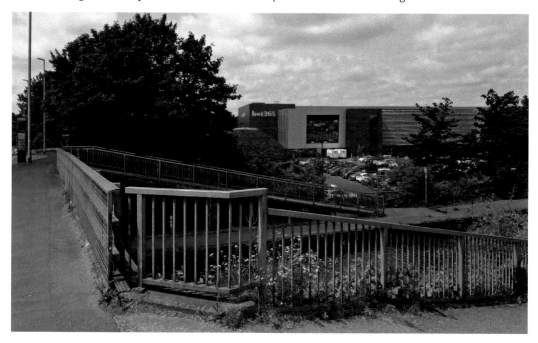

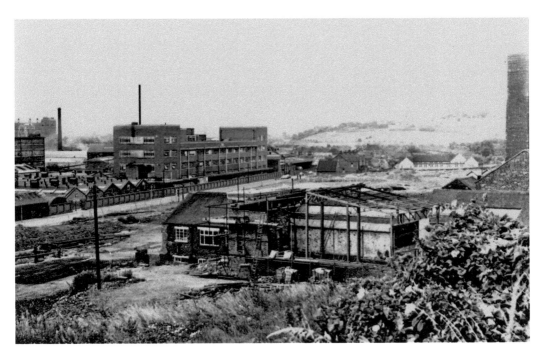

Etruria from Basford Bank, 1970 and Garner Street, Etruria, 2022

Twyford's Garner Street Works at Etruria was a short distance away from the company's main base at Cliffe Vale. The Cliffe Vale factory on Shelton New Road, built in 1887, was world-famous for its sanitaryware. The firm manufactured the one-piece Unitas pedestal toilet in 1883 which became the first and most successful free-standing wash-out toilet. In recent years, the old factory was restored and converted into flats. Two surviving bottle ovens overlook the Trent and Mersey Canal.

Sentinel HQ Site, Etruria, 1990s and Former Sentinel HQ Site, Etruria, 2022
That part of the present car park seen in the older photograph is now off-limits to the general public even if you ask nicely. *The Sentinel*'s headquarters were demolished in 2014 – the newspaper moving to Hanley – and another large company made its base here. The Roundhouse – the last remnant of Wedgwood's 1760s factory site – appears in both pictures. Josiah is said to have conducted engine experiments inside it. It is has sunk several feet below the level of the canal due to subsidence.

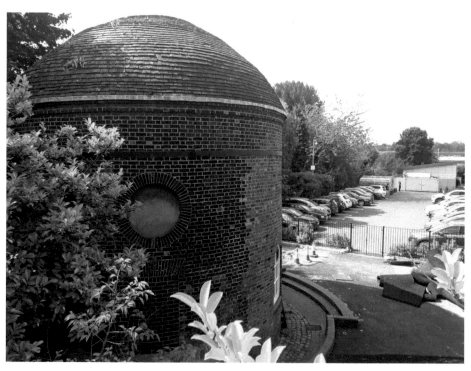

Ivy Cottages, Hartshill, 1969 and Tesco Express and Petrol Station, 2022
The Ivy Cottages near to Hartshill church accommodated labourers employed on the Cliff Vale estate of John Tomlinson. Built in the 1820s, they may have been Minton's inspiration when he built the Minton Cottages across the road in the late 1850s. The Ivy House Cottages were better-class dwellings though sanitary arrangements nearby were primitive. In 1879, it was reported that typhoid fever had killed three people living near to the cottages, the local drains and cesspools being in a defective state.

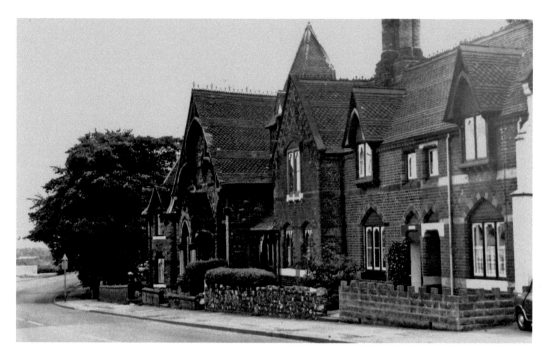

Minton Cottages, Hartshill, 1969 and 2022

When master potter and philanthropist Herbert Minton retired to Torquay in 1856, it fell upon his nephew Colin Minton Campbell to deliver his intention to erect several 'alms-houses'. They were built on Hartshill Road, conveniently near to Minton's pottery manufactories in Stoke, and part of a small-scale planned village, Hartshill church and church schools having already been built by Minton. The architect used was George Gilbert Scott. The Hartshill Institute, for the education and improvement of local 'mechanics', was added in the late 1850s.

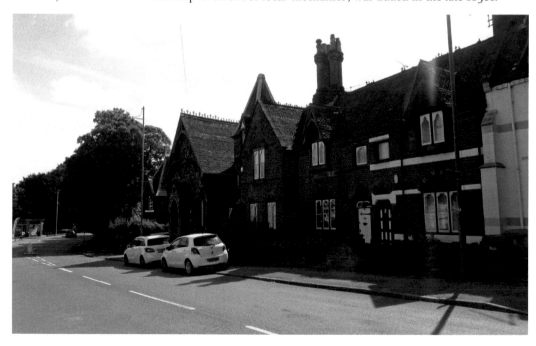

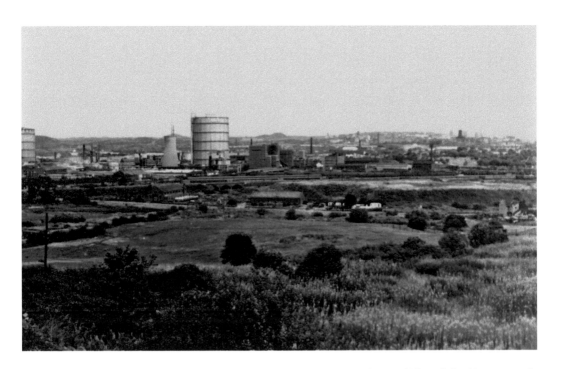

Hartshill Bank (top of) looking towards Etruria, *c.* 1970 and Hartshill Park looking towards Potteries, 2022

Countless trees block our view of the Potteries in the recent photograph, taken from Hartshill Park. The two gasholders in the top picture were built by the Etruria Gas Works and were targeted by German bombers during the Second World War. Jill Davenport's 2012 letter to *The Sentinel* revealed that as a child in Etruria, she and her friends would walk to the gasworks to collect coke in the winter. This was conveyed in various prams and trolleys back to their chilly homes.

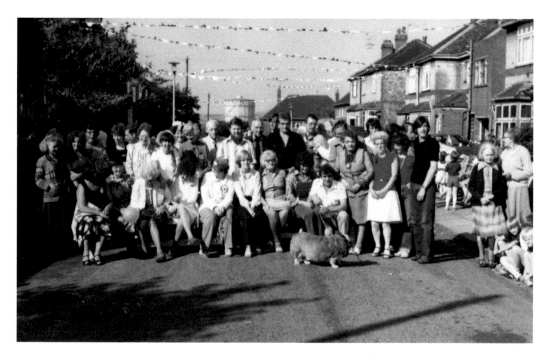

Stanley Road, Hartshill, Street Party for Royal Wedding, 1981 and Stanley Road, 2022
A surviving photograph shows a street party in nearby Steel Street on the occasion of the Coronation of Edward VII in August 1902. Here are the residents of Stanley Road showing that they, too, enjoy a royal event. Another community event is the so-called Hartshill Mile, a charity fundraiser involving visits to the various pubs and bars on Hartshill Road. In 2019, money was raised for the Macari Centre in Hanley which offers forty-eight 'living pods' for homeless people.

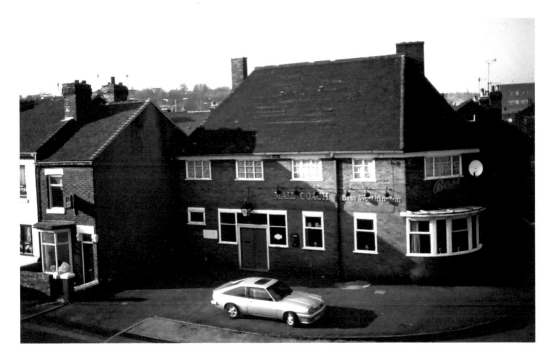

Mail Coach pub, Cliff Vale, 1996 and Former Site of Mail Coach, Garner Street, 2022
Situated between Shelton New Road and Etruria Road, Cliffe Vale developed from the end of the nineteenth century but with the arrival of the Potteries A500, began to fade from existence. Its local pub was described in the book *Potbank* (1961) by Mervyn Jones: 'The Mail Coach was new, probably replacing an older building of the same name. Little mail coaches, like those in the more arty Christmas cards, were everywhere: outlined on the windows, in glass bricks over the porch, and over the bars.'

Allan Townsend in St Thomas' Churchyard, Penkhull, with Royal Oak in Background, 1957 and Manor Court Street, 2022

Father Allan Townsend was born in Shelton in 1943. The building on the corner, at the top of Newcastle Lane, was the Royal Oak, which closed in 1912. Also in the frame is Penkhull Methodist church, built in 1836 and with an 1870s extension. There is an interesting reference in the local press of 1845 to Primitive Methodists being summoned for open-air preaching in Penkhull. In 1992, plans were drawn up by the Church for the demolition of the structurally faulty building which would have been replaced by a new structure. However, plans were refused by the City Council following concerns from the Potteries Heritage Society. The chapel closed in 1996 but was restored between 1998–9 and a landmark building in Penkhull was saved.

Allan Townsend in St Thomas' Churchyard, Penkhull, with East Street in Background, 1957 and Rothwell Street, formerly East Street, 2022

This street was renamed in honour of the Revd Frederick Rothwell, Vicar of Penkhull between 1928–30. Before the 1960s, it incorporated many old properties, some with front gardens, with Eardley Street radiating off it. A new housing development replaced these dwellings in the 1960s and a water feature was incorporated. Thus, Arthur Perry and the City Reconstruction Committee were instrumental in transforming the appearance of the Domesday Book village – a process that divided Penkhull's residents at the time. Ironically, Penkhull Village was given Conservation Area status in 1972 – a good example of shutting the stable door after the horse had bolted. Nevertheless, Penkhull has a thriving Residents' Association, cultural scene and indeed its own community flag, designed by local people in conjunction with Philip Tibbets and Graham Bartram.

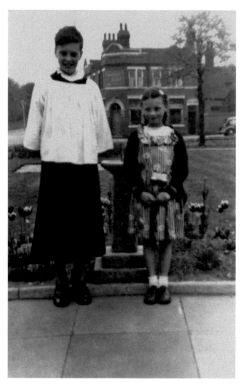

Allan Townsend in St Thomas's Churchyard, Penkhull with Marquis of Granby in Background, 1957 and St Thomas's with Marquis of Granby beyond the Trees, 2022
The Marquis, rebuilt in 1896, served Penkhull well over the years, hosting coroner's inquests, sales of property and farm produce and meetings of the Oddfellows friendly society and Penkhull Horticultural Society. The landlord held a live pigeon shooting contests in the 1860s and 1870s with fat pigs being offered as the winner's prize. A butcher's shop adjoined the premises, so perhaps the pigs were no trouble to procure. The Marquis had a bowling green attached. No fewer than six 'No Swearing' signs could be counted in the lounge in 2015 – when the landlords were the enterprising John Rowland and wife Carole – and these continuing high standards have helped to preserve the pub's status as a community asset. Allan Townsend was brought up in nearby Stoke but was educated in schools in Penkhull.

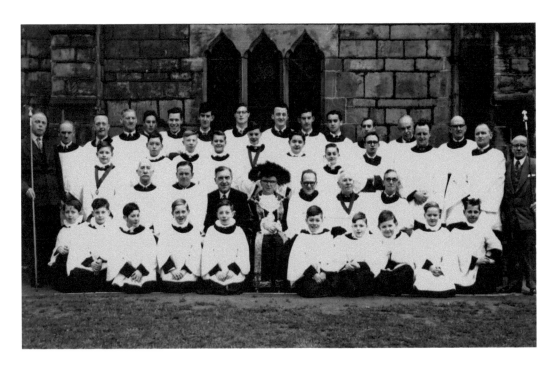

St Thomas' Church, Penkhull and Church Choir, 1957 and St Thomas's Church and Grounds, 2022
Conspicuous in the top photograph is Yorkshireman the Revd Arthur Perry, a Labour member of Stoke-on-Trent City Council for sixteen years who became Lord Mayor in 1957. He believed fervently that a parson should not be debarred from taking an active part in local government or party politics. A controversial figure, he will forever be associated with Penkhull's 1960s 'modernisation' – or what many local residents saw as the senseless and brutal destruction of historic buildings. He died in 1967.

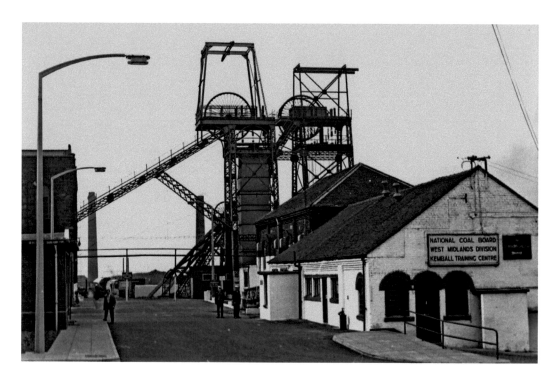

Kemball Colliery, Fenton, 1961 and Holiday Inn on Part of Former Kemball Colliery Site, 2022
The sinking of Kemball Colliery by the Stafford Coal and Iron Company Limited was begun in 1873 and completed in 1876. It mined coal and ironstone and there was a brickworks attached. The colliery would ultimately have four shafts: Pender, Bourne, Kemball and Hem Heath No. 1. In 1943, Kemball opened state-of-the-art training facilities for those entering the mining industry. It ceased coal production in November 1963. The Holiday Inn is near to Stoke City's Bet 365 Stadium.

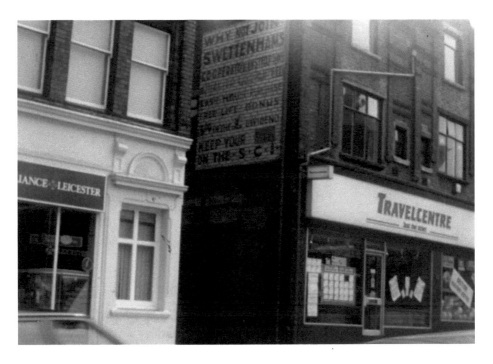

Buildings, Uttoxeter Road, Longton, Early 1990s and 2022

Note the 'ghost sign' between the two buildings advertising Swettenham's, whose Market Street, Longton, branch was advertised as being likely to open 'shortly' in the Staffordshire *Sentinel* of June 1929. SCI stood for Swettenham's Co-operative Institutions and there were branches in numerous North Staffordshire towns and villages. Victoria Buildings on the left carries the date of 1897 and is presently occupied by True hair salon and Lawson and Fern Limited Insurances. The ghost sign on the former Swettenham's premises has disappeared.

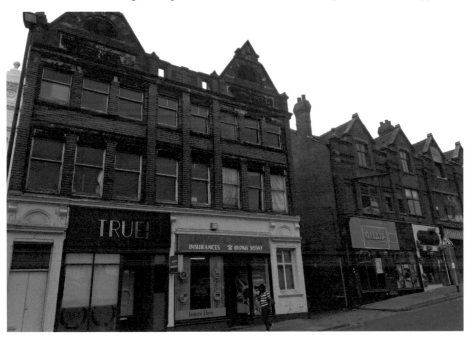

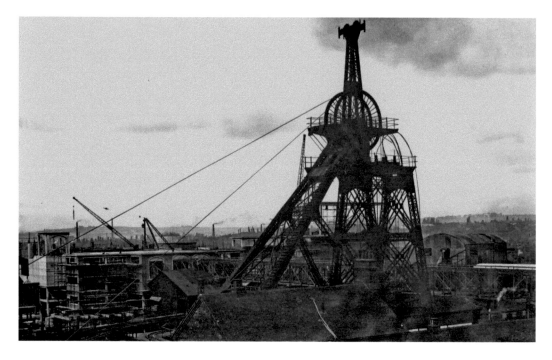

Florence Colliery, near Longton, 1951 and Florence Colliery Site from Lightwood Road, 2022
The colliery was named after the 3rd Duke of Sutherland's youngest daughter and was initially worked by him as a private concern. The sinking of its shafts began in 1874 and a third shaft had been sunk by 1916. Underground connections were made with Parkhall and Hem Heath collieries. Florence and Hem Heath were later merged to become Trentham superpit. The bronze plaque attached to the gatepost that formed part of the entrance to the old site was the idea of historian James Brooks.

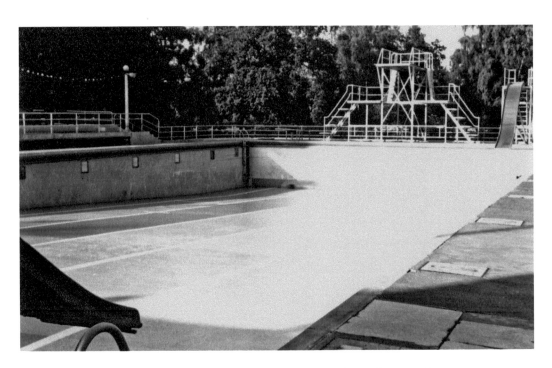

Swimming Pool, Trentham Gardens, probably 1960s and Trentham Gardens Entrance, 2020
Trentham Gardens was dubbed in the 1930s 'The Beauty Spot of England' with its outdoor swimming pool being opened in 1935. It was 132 feet by 60 feet in dimension and was situated amongst woodland scenery. It was later damaged by subsidence and demolished in 1986. The present monkey forest at Trentham occupies part of the site of the swimming pool and is only one of numerous visitor attractions at Trentham, which remains one of the jewels in the crown of North Staffordshire.

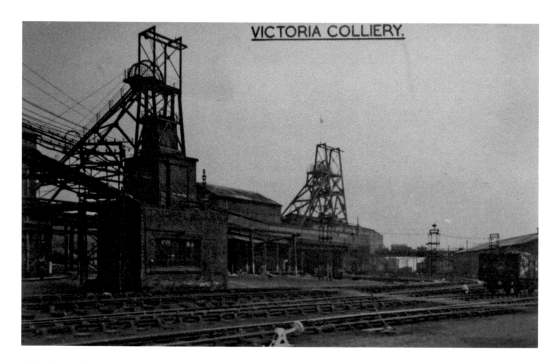

VICTORIA COLLIERY.

Victoria Colliery, Biddulph, probably 1947 and Biddulph Town Hall and Victoria Colliery Pit Wheel, 2022

This colliery was actually situated at Brindley Ford and known locally as the Bull or the Black Bull. It had five shafts: Victoria, Havelock, Salisbury and two at Brown Lees. In the top picture, Havelock is left with Victoria centre. The colliery closed in July 1982 and in 1989 the balance wheel from the bottom of the Victoria shaft was placed in front of Biddulph Town Hall as a permanent memorial of the town's mining industry.

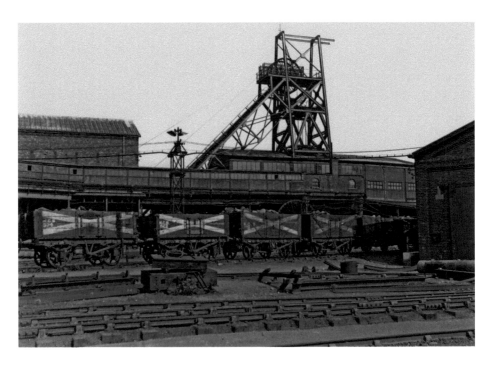

Victoria Colliery, Biddulph, Havelock Pit, 1951 and Victoria Colliery Pit Wheel, 2022
In 1949, miner Edwin Mould retired after sixty-three years underground – fifty-six of them at Victoria. The colliery was one of the wettest in the North Staffordshire coalfield. Following the pit's closure, the Salisbury shaft was kept open for the purpose of pumping water so as to protect nearby Chatterley Whitfield Mining Museum – whose visitors descended the Winstanley shaft – and Wolstanton Colliery. Pumping continued until Wolstanton Colliery closed in the mid-1980s.

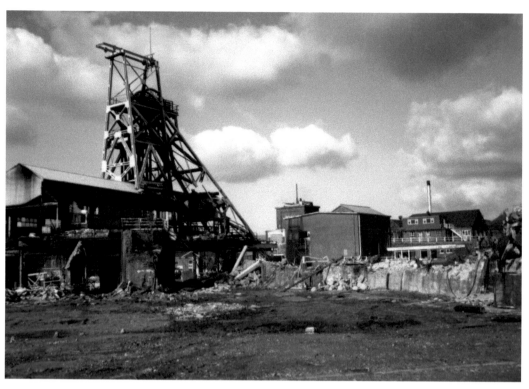

Victoria Colliery, Biddulph, Demolition of Headgear, 1983 and Victoria Colliery, Former Site, 2022, with Ian Barber and David Walley

With the demise of the colliery, the 300 or so remaining miners were offered jobs at other local collieries, chiefly at Hem Heath and Florence. Salvage work began on site. The Victoria Business Site recalls the name of the former colliery and our picture shows two senior members of Biddulph Male Voice Choir on site. The choir – whose original members were drawn from the ranks of the Biddulph mining community – organised a centenary concert in September, 2022.

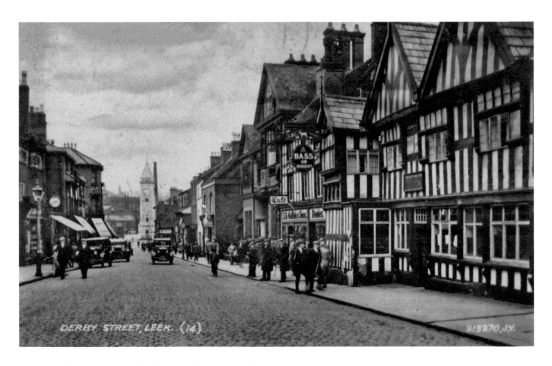

Derby Street, Leek, date unknown and Same, 2022

Derby Street remains the heartbeat of the town of Leek and over the years has boasted of diverse shops. They included Thomas Mark, the printer and stationer, which produced an annual almanac containing a directory of traders. Rival Derby Street printers were W. Heaton, Hill Brothers, John C. Fogg and C. Kirkham. Other traders included Peter Magnier, the baker, confectioner and provision dealer, Deakin's Cooperage and Hunter's ('for good tea and good butter').

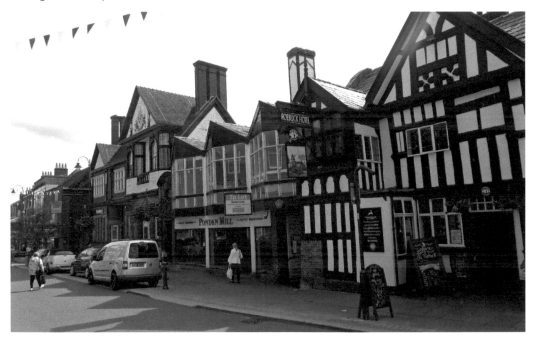

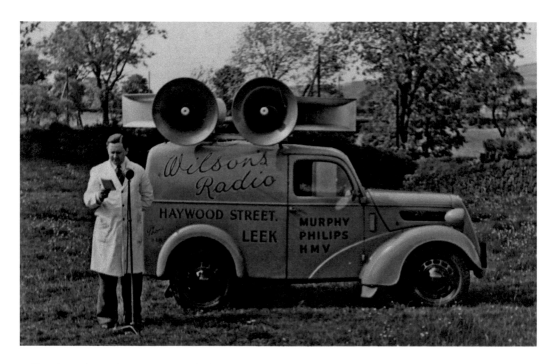

Wilson's Radio Delivery Van, probably Late 1950s and Scorpio Fast Food, Haywood Street, Leek, 2022

Family information on Wilson's shop at 69 Haywood Street, Leek, indicates that it was opened as a radio shop by James ('Jim') Wilson sometime during 1933. The telephone number was Leek 345. The shop stood opposite the old Cattle Market and many customers were farmers wishing to buy radios and perhaps acid batteries, perhaps after a good animal sale. No televisions were available until the 1950s other than experimental sets. The shop closed in 1963.

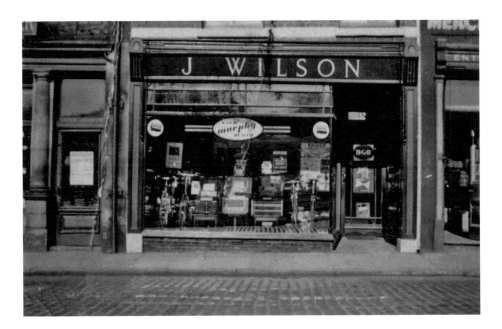

Wilson's Radio and TV Shop, Leek, probably 1960s and Scorpio Fast Food, Haywood Street, Leek, 2022

Although Leek remains an attractive destination for shoppers, Mr Wilson's shop is long gone. Other shops that will be remembered by the older generation would be Peacock's Ladies Fashionwear in Stockwell Street, Smarty Pants boys' outfitter in St Edward Street, Christopher Kunz's furniture shop in Broad Street, Ryder's Delicatessen in Fountain Street and Peter James' carpet shop in Stanley Street and J. Sherratt's leatherware shop in Derby Street, which sold handbags, gloves and purses.

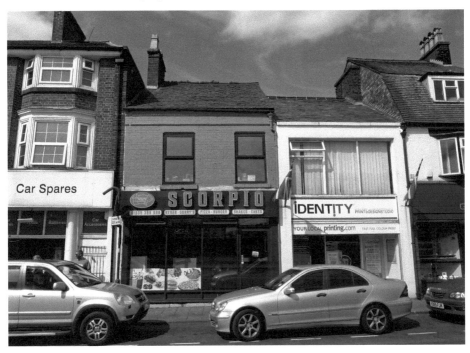

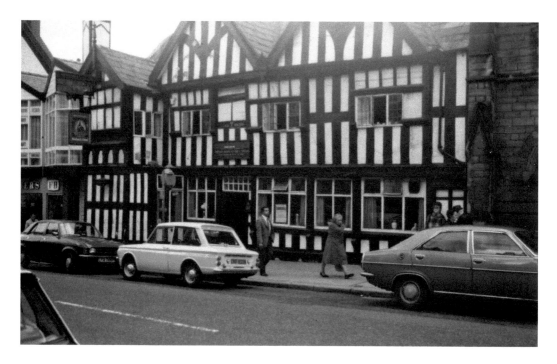

Roebuck Inn, Derby Street, Leek, 1977 and Same, 2022

The date of 1626 is often given for the Roebuck – and almost as often, disputed. This and the Red Lion were the chief coaching inns in Leek – and both pubs were able to change with the times. From 1849, omnibuses ran from both pubs to the railway station. The Roebuck was Grade II listed in 1951, acknowledging its timber frame, Welsh slate roof and other points of interest. Titanic Brewery took over the pub in 2012.

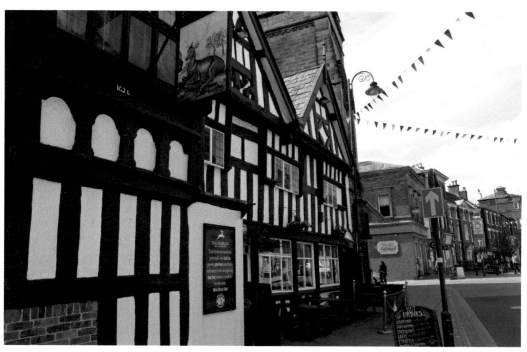

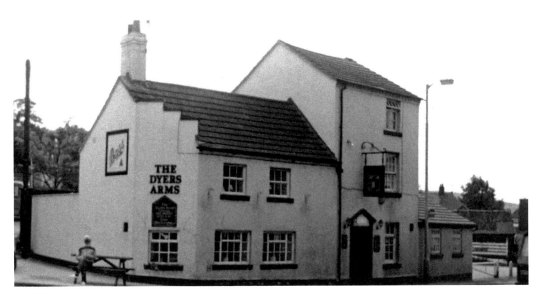

Dyers Arms, Macclesfield Road, Leek, 1990s and Same, 2022
Leek-based historian Neil Collingwood traces this outlet back to 1833 when it was merely a beerhouse. Perhaps it did well to survive in its later guise as a fully licensed pub. When licensee Raymond Pugh applied for a singing and music licence in 1933, Superintendent Clarke opposed: 'In my opinion, it is not structurally fit to be a public house,' he attested. Licensee Kevin Lewis was the manager of Leek Town in the 1980s.

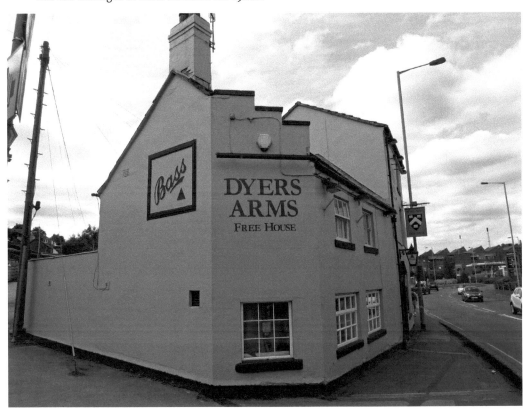

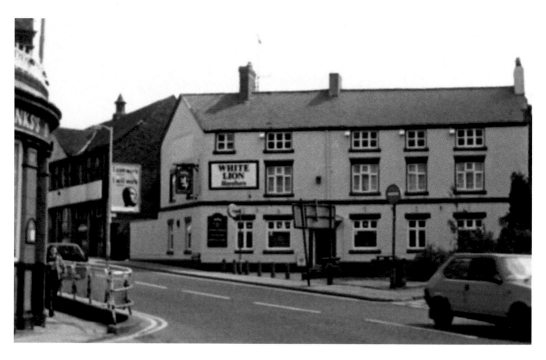

White Lion, Ashbourne Road, Leek, 1990s and Former Pub, 2022
Two former pubs appear in this photograph. On the edge of the photos is the Talbot Inn, once the Rodney's Head and then the Spread Eagle. It was rebuilt in 1878 and was lucky not to be destroyed in a serious blaze in 1991. It became a Premier Inn in 2014. At least these buildings survive in Ashbourne Road, even if the old pubs closed. The Flying Horse, further up the road, fared rather worse, being demolished in 2021.

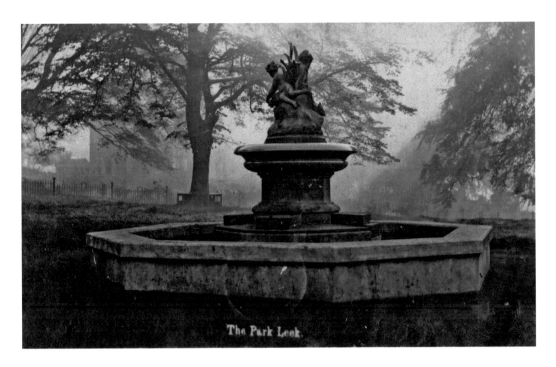

The Park Leek.

Brough Park, Leek, date unknown and 2021

Brough Park was laid out on part of the Ball Haye Hall estate. A bandstand was built in the same year. The Victoria County History reveals that a fountain given by William Challinor and designed by Joseph Durham was erected on the site of the hall in 1876. It was moved to Brough Park in the year of the park's official opening in 1924 but the water was cut off in 1975 as the fountain had been vandalised. It was removed in 1988.

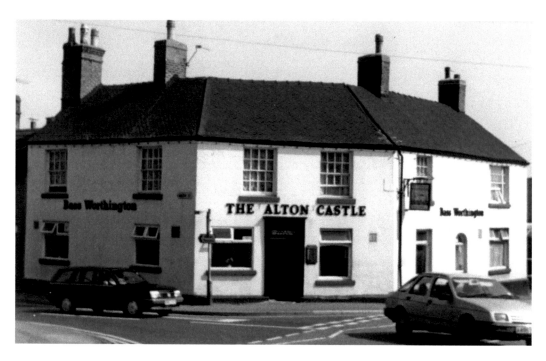

Alton Castle Pub, Tape Street, Cheadle, 1990s and Former Pub, 2022

Cheadle is a market town that may boast a market cross – as well as St Giles', a beautiful Gothic Revival Catholic church with a 200-foot steeple designed by A. W. N. Pugin. The 1984 CAMRA Potteries beer guide noted that the pub had retained its original Bass etched windows. It closed in 2018 and in June 2021 it was announced that an application for change of use into a Domino's takeaway had been approved.

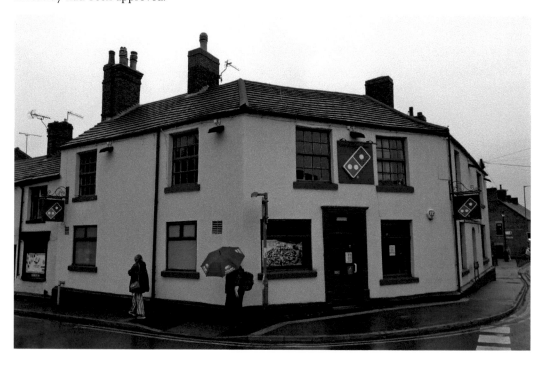

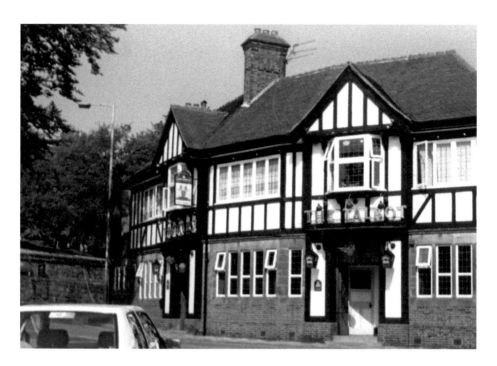

Talbot Pub, Watt Place, Cheadle, 1990s and Former Pub, 2022

In the nineteenth century, the Talbot was popular with visitors to Cheadle Wakes, which took place in September, attracting people from the Potteries and beyond. In the 1880s, Mr Wright, the landlord of the Alton Castle Inn, had a hand in arranging the sports that took place during the wakes. The pub was a draw for music fans in the 1980s with the likes of Lee Johns (organist and compere), Bill Montana, Steve Fenton, Deek Rivers and Simon Smith entertaining patrons.

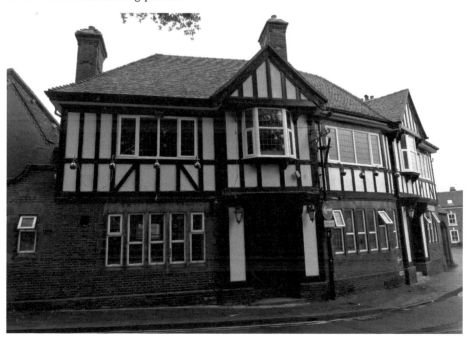

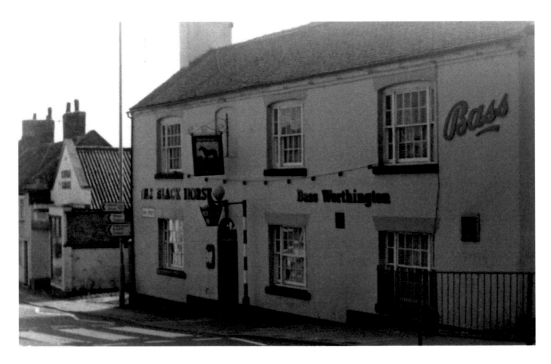

Black Horse Pub, Cheadle, 1990s and Former Pub, 2022

This former pub was Grade II listed in 1986, recorded as being probably built as an inn and of nineteenth-century origin. In 1995, the local press reported that pensioner May Smith, seventy-nine, had sat in the same seat for sixty years. Following discussions with Enterprise Inns, this seat, initially due to be ripped out, was retained. Unfortunately, no one sits in the pub now, as Cheadle's pub stock has dwindled. A Wetherspoon's pub, the Wheatsheaf, trades in the High Street.

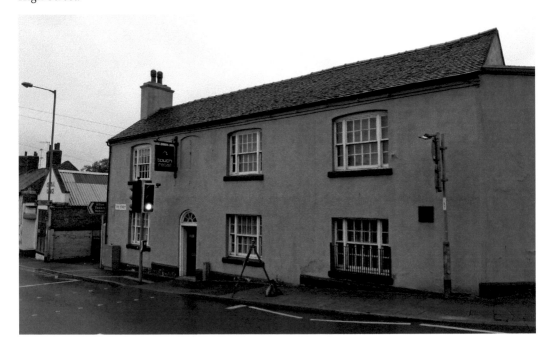

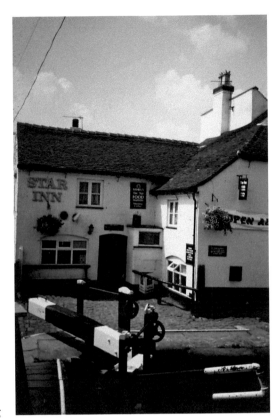

Star Inn, Stone, 1994 and 2022
The Star Inn, overlooking a lock,
pre-dates the Trent and Mersey Canal,
having existed since the sixteenth
century. It was fully licensed in 1819 and
prospered through the canal trade, having
stabling for twelve horses. A plaque on
the wall commemorates the opening of
the canal in 1777 whilst another notice
informs us that the pubs is listed in the
Guinness Book of Records as the English
pub with more levels than any other.

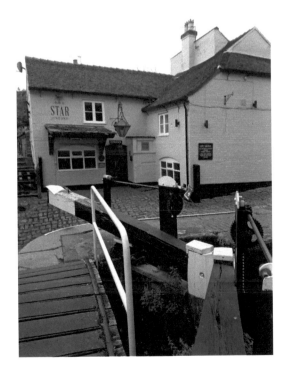

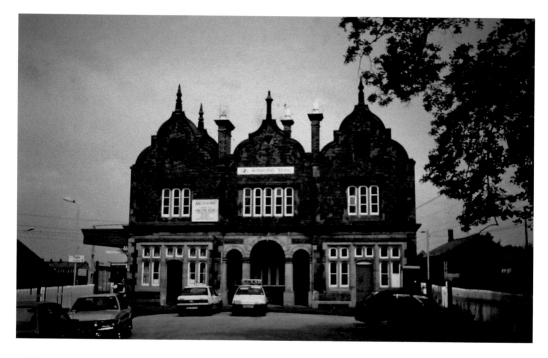

Railway Station, Stone, 1994 and 2022

Stone railway station was opened by the North Staffordshire Railway on 17 April 1848, next to the Newcastle Road bridge but with the opening of the Colwich line on 1 May 1849, it was closed and supplanted on the same day by the present building. For many years it was known as Stone Junction. The station was designed in the Tudor style by H. A. Hunt and was Grade II listed in 1972.

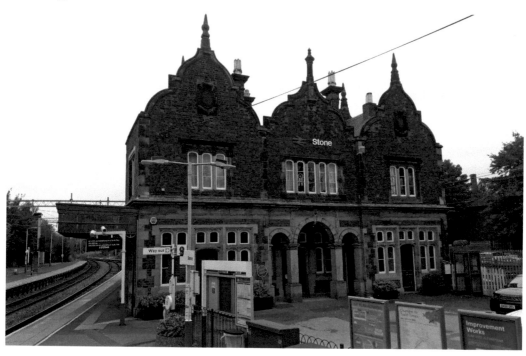